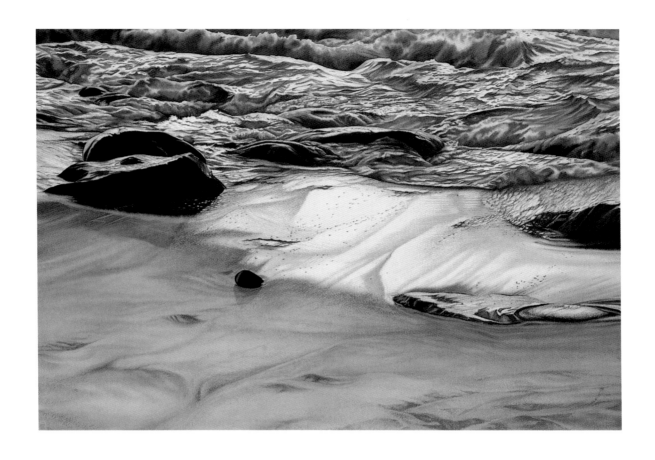

Light up your Watercolors
L A Y E R *by* L A Y E R

Linda Stevens Moyer

NORTH LIGHT BOOKS

CINCINNATI, OHIO
www.artistsnetwork.com

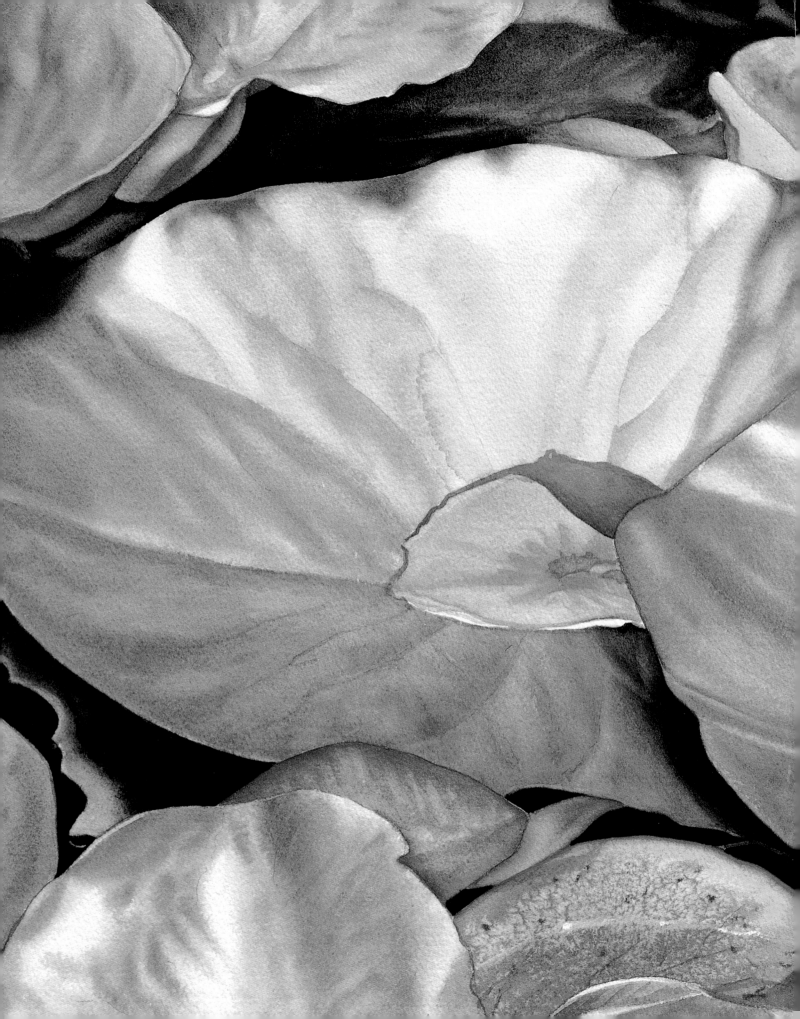

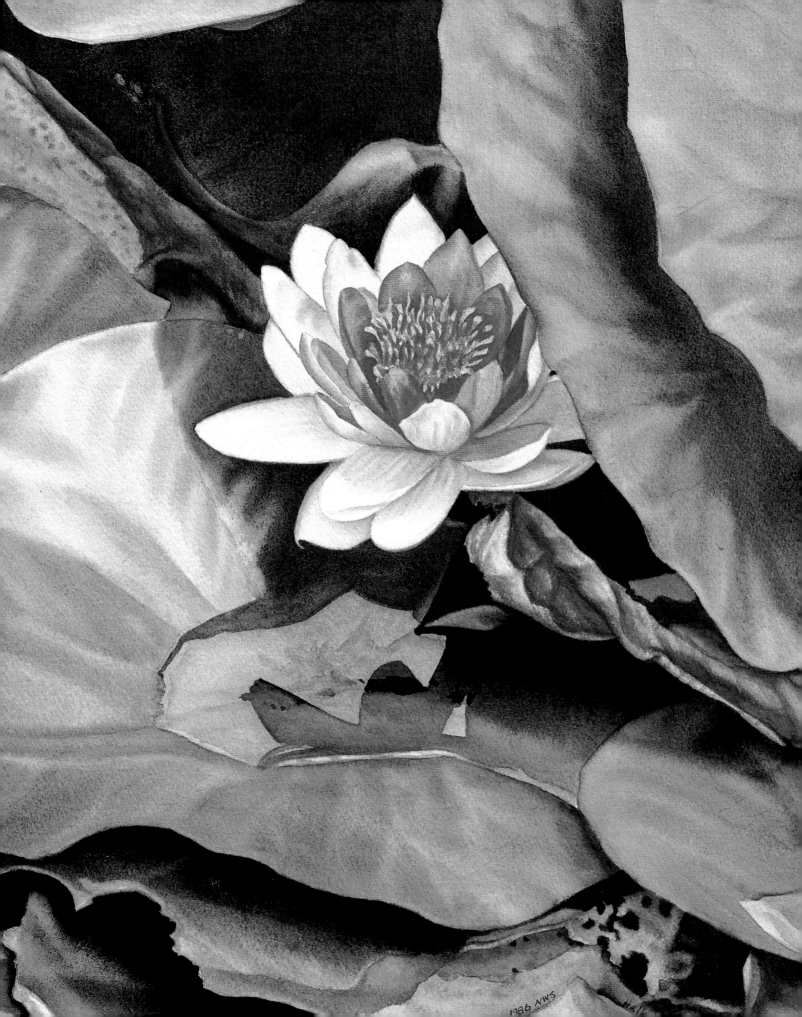

1986 NWS

ESTELLE
Linda Stevens Moyer
Transparent watercolor
$29^{1}/_{2}" \times 42"$ *(75cm × 107cm)*
Collection of the artist

I dedicate this book to my mother, Estelle Leona Beaty Moyer. I am grateful for her playful imagination which nourished my life and creative spirit.

10 09 08 07 06 7 6 5 4 3

Library of Congress Cataloging in Publication Data
Moyer, Linda Stevens.
 Light up your watercolors layer by layer / Linda Stevens Moyer.— 1st ed.
 p. cm.
 Includes index.
 ISBN-13: 978-1-58180-189-7 (alk. paper)
 ISBN-10: 1-58180-189-0 (alk. paper)
 1. Transparent watercolor painting—Technique. I. Title.

ND2430 .M69 2003
751.42'2—dc21
2002034653
CIP

EDITOR: Stefanie Laufersweiler
COVER DESIGNER: Wendy Dunning
INTERIOR DESIGNER: Brian Roeth
LAYOUT ARTIST: Tari Sasser
PRODUCTION COORDINATOR: Mark Griffin

F+W PUBLICATIONS, INC.

METRIC CONVERSION CHART

To convert	to	multiply by
Inches	Centimeters	2.54
Centimeters	Inches	0.4
Feet	Centimeters	30.5
Centimeters	Feet	0.03
Yards	Meters	0.9
Meters	Yards	1.1
Sq. Inches	Sq. Centimeters	6.45
Sq. Centimeters	Sq. Inches	0.16
Sq. Feet	Sq. Meters	0.09
Sq. Meters	Sq. Feet	10.8
Sq. Yards	Sq. Meters	0.8
Sq. Meters	Sq. Yards	1.2
Pounds	Kilograms	0.45
Kilograms	Pounds	2.2
Ounces	Grams	28.4
Grams	Ounces	0.035

ART FROM PAGE 1:

detail of THE THIRD DAY #2
Linda Stevens Moyer
Transparent watercolor
$37^{1}/_{2}" \times 42"$ *(95cm × 107cm)*
Collection of Dr. and Mrs. David Tonnemacher, Glendale, California
Photograph by Gene Ogami

ART FROM PAGE 2-3:

HAIKU #10
Linda Stevens Moyer
Transparent watercolor
$29^{1}/_{2}" \times 42"$ *(75cm × 107cm)*
Collection of Mr. and Mrs. Joe Hauch, Palm Beach, Florida
Photograph by Gene Ogami

About the Author

Linda Stevens Moyer holds a bachelor's degree in art as well as two master's degrees. She has exhibited in numerous juried, group and invitational shows as well as eleven solo shows. The Laguna Art Museum and the Maturango Museum both have hosted her work in one-person exhibitions. She is the recipient of the American Watercolor Society Gold Medal of Honor and Walser S. Greathouse Medal; First Award in Watercolor West; Allied Artists of America Gold Medal of Honor for Watercolor; Utah Watercolor Society Best of Show; and a number of other national and international awards.

Moyer's work has been featured in numerous books, including *Make Your Watercolors Look Professional* by Carole Katchen, *Enliven Your Paintings With Light* by Phil Metzger, *Splash 1* and *Splash 2* (published by North Light Books); *Understanding Transparent Watercolor* and *Exploring Painting* by Gerald F. Brommer; and various publications of *The Artist's Magazine* and *American Artist*. She is listed in *Who's Who in American Art, Who's Who of American Women, Who's Who in the West* and *Who's Who in the World*.

Moyer's paintings are found in prominent private collections as well as the following corporate collections: Home Savings of America; National Bank of La Jolla in California; Greenburg Deposit Bank in Ashland, Kentucky; and the permanent collection of the Springville Museum of Art in Utah.

Moyer is co-founder of the Internet site Watercolor Online (www.watercolor-online.com), which is dedicated to the promotion of aquamedia and aquamedia artists. She is a signature member of the National Watercolor Society and Watercolor West and is a past president of Watercolor West. An experienced educator, lecturer and juror, she has instructed in college and university classes as well as workshops nationwide.

Acknowledgments

I would like to acknowledge the following people:

My wonderful husband, Brock David Williams, who believes in me and my work.

My son, Metin Ata Gunsay, one of my life's greatest blessings; his wife, Melanie Adams Gunsay, wonderfully talented in her own right; and my sweet grandchildren, Brieanna, Asher, Seth and Noelle.

Friends and former students, now established artists, who allowed their earlier work to be included in the book.

My editor, Stefanie Laufersweiler, who guided me through the process of creating this book… and made it fun.

TABLE OF CONTENTS

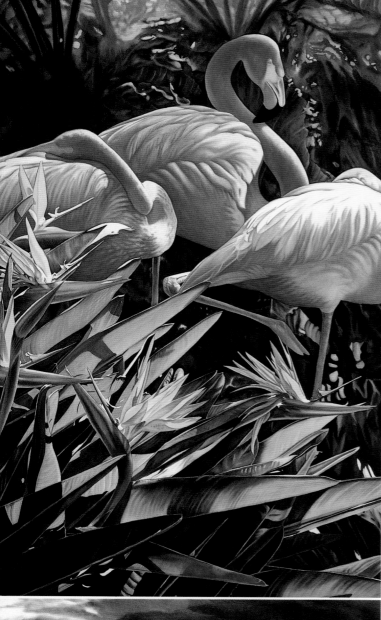

HAIKU #2
Linda Stevens Moyer
Transparent watercolor
40" × 60" (102cm × 152cm)
Private collection
Photograph by Gene Ogami

INTRODUCTION

■ TRANSPARENT WATERCOLOR IS A CHALLENGE.
It has been called one of the most difficult mediums to master. It is true that there are certain rules to follow in creating a painting in transparent watercolor—perhaps more than in a number of other mediums. However, once the rules (or procedures) become part of the painter, I don't believe that there is a more beautiful way of expressing any subject matter.

There are many different "looks" to transparent watercolor. The most popular misconception is that watercolor paintings must be small, pale, watery compositions. On the contrary, watercolors may be mural-sized, bright, detailed and filled with strong values. The look depends on the expression of the individual artist.

I have found through years of teaching that a structured foundation will make for a confident painter. I believe that structure in learning leads to freedom of expression. What I intend to give you with this book is a good foundation. The first half of the book covers the basics of painting in transparent watercolor. The second part will introduce you to the more advanced concepts of layering with color and creating luminosity in your paintings.

Assignments throughout will give you the opportunity to practice and to gradually become proficient in each technique. Each chapter builds on the information in the previous chapters. Each lesson depends on mastering the ones before it. You will find that doing an assignment a second time will give you a greater understanding of it. We definitely learn from our mistakes!

A lot of material is covered in this book. However, you will find that by applying the information systematically, you will be greatly rewarded in terms of your progress as a watercolorist. With practice, you will become fluent in the language of color and light, and obtain the skill to create luminous compositions in the beautiful medium of transparent watercolor.

Materials

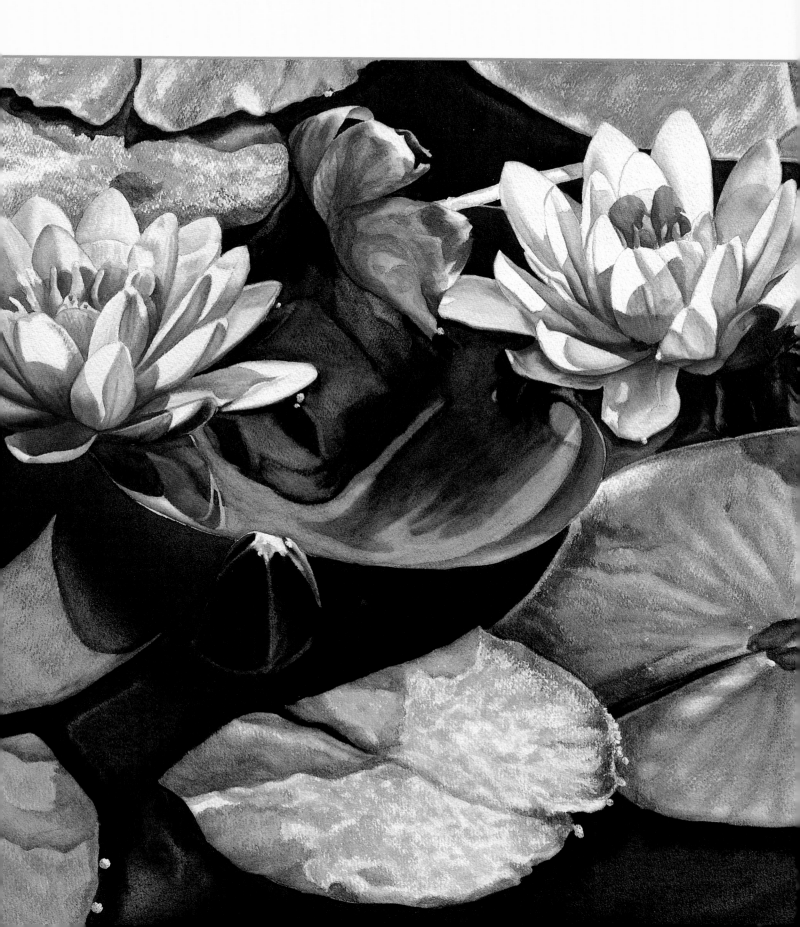

ARTIST'S MATERIALS CAN BE VERY

expensive. For this reason, I have taken care to include only those things which I think will be essential to your development as a painter. Beginning painters usually start out with materials of lesser quality, until they achieve a certain mastery of the medium. In learning to paint with transparent watercolor, it is essential to work with good products from the very beginning.

HAIKU #12
Linda Stevens Moyer
Transparent watercolor
22" × 30" (56cm × 76cm)
Collection of Dr. Peter Hirsch, Torrance, California
Photograph by Gene Ogami

Paint

Be sure to buy paint that is labeled *transparent* watercolor. There are many different kinds of water-soluble paints: designer colors, gouache, casein, tempera, acrylics, etc. These are not used for transparent watercolor paintings.

The best transparent watercolors come in tubes, are finely ground with granite rollers and have very saturated (or intense) color. The ground pigment is combined with gum arabic to make the paint adhere to the paper surface. Glycerine or honey or various sugars are added to keep the paints moist and water-soluble.

A number of manufacturers have two grades of paint: professional and student. The professional paint is, of course, much more expensive. The beginning artist will do fine with the student-grade paint for a while. You will discover, however, that once you begin to use professional colors, you can never go back to the less expensive grade. Professional watercolors are more finely ground; the color is more intense. You will find that these qualities make the color in your paintings more vibrant. The paint will actually go farther because of the greater saturation of color, and perhaps, over time, save you money.

There are many different colors of paint that you can buy. For the assignments in this book you will need only ten tubes of paint: the primary colors, two secondary colors, and some earth colors. It is best to look at the chemical formula name on the paint tube rather than going by the manufacturer's name in order to buy the appropriate color. The palette on this page shows the colors that we will be using. Later, you may wish to expand your palette to include some of the other beautiful colors in a product line.

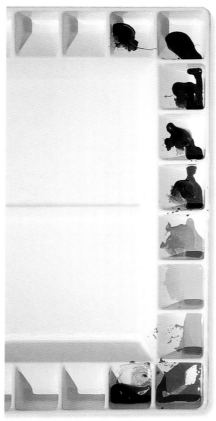

PAYNE'S GRAY

ULTRAMARINE BLUE (AKA FRENCH ULTRAMARINE)

PHTHALO BLUE

PHTHALO GREEN

BURNT SIENNA

YELLOW OCHRE

CADMIUM YELLOW PALE

CADMIUM ORANGE

QUINACRIDONE RED

ALIZARIN CRIMSON

My Palette

I always organize my palette with the paint colors grouped in this order: warm colors first, earth colors in the middle and then the cool colors. Having the colors in the same place on your palette each time you work will make your work time more efficient. You won't have to search for them; you will always know exactly where they are.

You will want to buy 15-ml tubes of paint. These are more economical, so you won't be tempted to put too little paint in your palette. Your palette should have a good squeeze of each color recommended for the individual assignments in this book. Because the paint is water-soluble, even if it dries out in your palette, you should be able to reconstitute it by adding a few drops of water.

I don't recommend that you squeeze an entire tube of paint into the individual wells. Some instructors have their students do this, but as time passes, the color will leach out from the upper layers of the paint and leave a crusty residue that will not provide the pure paint colors you need in your paintings.

Brushes

It is of prime importance to have a good brush. However, that doesn't mean that you have to invest in a top-of-the-line kolinsky sable brush. There are a number of watercolor brushes on the market that are made of synthetic fibers that work very well and are very affordable.

The brushes I use are Robert Simmons white sable (synthetic fiber). They come to a very nice point and are quite durable. They do not hold as much paint as a kolinsky sable brush—and they are a little stiffer—but their affordability makes up for these two factors.

I use a large, flat brush to cover large areas with paint or water. I have found the round brushes to be more versatile and expressive when creating lines and washes in transparent watercolor.

Some manufacturers combine synthetic fibers with natural sable or sableline to make a very usable brush at a low cost. The addition of the natural animal hairs increases the amount of paint the brush can hold and also makes a softer brush.

Many "bargain" brushes will not be good investments. They may grow quite limp as you work on a painting and at times the bristles will fall out. The handles will come loose from the ferrule, and the ferrule itself may rust. It is best to buy brushes from a recognized art materials manufacturer. Experiment with different brands, kinds and sizes to see what you like.

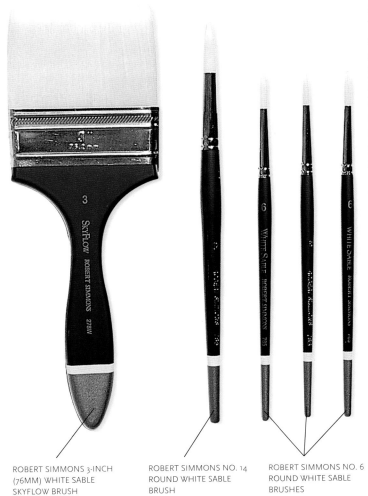

ROBERT SIMMONS 3-INCH (76MM) WHITE SABLE SKYFLOW BRUSH

ROBERT SIMMONS NO. 14 ROUND WHITE SABLE BRUSH

ROBERT SIMMONS NO. 6 ROUND WHITE SABLE BRUSHES

My Brushes
The large flat brush doesn't have to be an artist's brush; it could just be a soft, wide flat brush from your local hardware store. In addition to a larger round (no. 12 or 14), you'll want several small round brushes (nos. 3 to 6) that come to a good point.

Brush Care | TIPS

Here's how to get the most from your brushes:
- Wash your brushes in cool water immediately after your painting session.
- Pat the bristles carefully with a paper towel and gently pull the bristles out to a point, making sure that none are bent. This should guarantee a good point for the next time you use it.
- Dry your brushes on a flat surface. Storing your wet brushes vertically will make the water run down into the ferrule of the brush and may dissolve the glue that holds the handle to the ferrule.

- If your brush has come into contact with another object during its storage and the point is bent, you can remedy this by doing the following: **(1)** Make a very thick lather from a bar of hand soap. **(2)** Apply this lather to the bristles of your brush. **(3)** Form a point with the bristles. The lather should be thick enough to hold the brush in the desired form. **(4)** Let the brush dry completely. **(5)** Rinse the soap from the brush completely. You should have a brush with a restored point and no bend.

Paper

The best watercolor paper is made from 100 percent alpha cellulose (linen or cotton linters) and is sized, mouldmade and buffered. A sheet of paper that has been made from alpha cellulose is strong, durable and will not readily yellow as wood-pulp paper does.

Sizing (usually in the form of warmed gelatin glue) is added to the paper to reduce its absorbency and to give it added strength. It also affects the luminosity with which the watercolor washes will dry. When a paper is internally sized, it means that the sizing was added in the process of making the paper from the fibers. External sizing is a coating that is applied to the surface of the paper after the sheet has been formed. Paper that is double-sized has been internally and externally sized.

Watercolor paper generally comes in three different surface textures: rough (R), cold-press (CP) and hot-press (HP). Rough paper is significantly textured and cold-press is moderately textured. Both types of paper are the result of additional pressure during the papermaking process. Hot-press paper has a very smooth surface and is the result of the application of heat during the papermaking process.

The weight of the paper is determined in two different ways: (1) It may be based on the weight in pounds of a ream (500 sheets) of the parent size of watercolor paper (22" × 30"). If a ream of watercolor paper weighs 140 pounds, we say that a single sheet of that paper is 140 pounds. (2) In the metric system, the weight is determined by the weight in grams of one square meter of paper. In this system, 140-lb. paper is designated as 300 grams per square meter (300gsm). You will probably see both paper weights listed on the paper that you buy. Other common paper weights used in transparent watercolor are 300-lb. (640gsm) and 90-lb. (190gsm).

I recommend that the beginning artist buy the best paper possible of at least 140 pounds (300gsm). This expense will be worth the reduced frustration in learning how to create a transparent watercolor. Using a poor-quality paper will thwart the best efforts at learning this medium. Because I layer extensively when making a painting, I need a surface that will withstand a lot of work. I use Arches 300-lb. (640gsm) rough paper almost exclusively.

Deckle Edge

The deckle edge is formed during the mold process. It has an organic quality that is compatible with the subject matter of my paintings. I sometimes mat and frame my paintings so that this edge shows in the finished presentation.

Which Surface Should I Use?

ROUGH

- The rough texture of this surface makes painting details a little more difficult.
- You may want to consider the texture of the paper in terms of its compatibility with your subject matter. For example, if you are painting rough rocks or tree bark, this might be an ideal surface to emphasize organic qualities.

COLD-PRESS

- The smoother texture makes the surface more receptive to watercolor paint.
- Many artists prefer this watercolor paper as it is more versatile than either the rough or the hot-press paper.
- Small details are easier to paint because the texture of this paper doesn't interfere with the brushstroke as much as rough paper does.

HOT-PRESS

- The very smooth texture of this paper makes it easier to lift from the surface than the other papers. The heating process used to make this paper seals the surface so the paint doesn't penetrate as deeply.
- This would be an ideal paper to use for illustrations.

Other Supplies

Here are other supplies you'll need to gather before you begin painting:

PALETTE—Buy the largest palette you can afford. There will never be enough mixing room. Find one with a number of wells for your different colors, and large mixing areas. Some come with covers that will help keep your paint moist between painting sessions.

DRAWING BOARD—A board that is at least 26" × 34" (66cm × 86cm). A piece of $\frac{1}{2}$-inch (1cm) plywood that has been varnished makes a good surface. You can add a drawer pull to the edge to make it easily portable.

TABLE EASEL—The size of the easel will depend on how large you intend to work. I recommend one that will easily hold the above drawing board. You'll also want one that can be adjusted to several different angles of incline.

SKETCHBOOK—The sketchbook should be of drawing paper and any size that is convenient for you.

PENCIL—A pencil that is too soft will leave smudges on your paper. One that is too hard will emboss the paper. Usually, an HB pencil will be appropriate. Most of the standard no. 2 yellow pencils that we see in use are equivalent to the HB pencil (and are much less costly than a "drawing" pencil).

ERASER—A gum eraser is probably the best since it crumbles away as it is used, and the oils from your hands are not retained on its surface. This is why I don't suggest using a kneaded eraser. It is important that oil not be transferred to the paper, because it will make the surface repel your watercolor. It's very upsetting to discover this in the midst of a painting!

WATER CONTAINER—This can be just about anything; an empty margarine

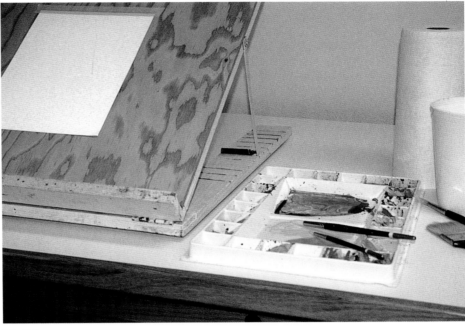

My Setup
Your setup may look something like this. I have my palette, water container, towels and other materials to the right of my table easel because I am right-handed. This makes for easier access and it helps to eliminate stray drips that might occur if the arrangement were reversed. I usually don't sit when I paint. I like to walk around and gain different perspectives of the painting as I work.

or whipped topping tub works just fine. Be sure that it is large enough to provide clean water for rinsing your brushes over an extended time. (Be sure to replace the water periodically as you work.)

ART MASKING FLUID—This is a product that will help you save the white of the paper as needed. There are many brands on the market. Look for brands that are easy to remove from your paper once your painting has been completed.

PAPER TOWELS—These will be used continuously during the painting process: to clean your brush, to remove excess paint from your brush after loading it with color, to lighten colors that have been applied to the paper by blotting, and even to create texture.

LARGE PAD OF NEWSPRINT—A pad that is at least 18" × 24" (46cm × 61cm). We'll use this paper for some of the assignments in the book. Later on, you may find it useful for planning compositions.

RECTANGULAR HOUSEHOLD SPONGE (RESERVED FOR YOUR PAINTING KIT ONLY)—Your sponge can be used to apply water to your paper, to create textures and also in stretching your paper.

BROWN PAPER TAPE WITH WATER-SOLUBLE ADHESIVE, AND STAPLE GUN OR THUMBTACKS—These items will be used for stretching and securing your paper.

STRETCHING YOUR PAPER

Watercolor paper will tend to buckle when you paint on it. This may become quite problematic if you are using one of the lighter weights of watercolor paper. It is difficult to paint on paper that is buckling as the paint tends to run down into the "valleys." There are two ways of avoiding this:

1. Buy paper that is of greater weight. I work on 300-lb. (640gsm) paper to avoid much of this effect.

2. Stretch your paper. Do this by wetting the paper so that it expands and then taping it down so that it will remain in this stretched position. Paper that is under 260-lb. (550gsm) should probably be stretched before you work on it.

This demonstration will show you how to properly stretch your paper. You may become proficient enough to get a good stretch with only the brown paper tape. The tacks or staples help ensure good results. Don't give up if your paper doesn't stretch well the first few times. Most people don't get a perfect stretch the first time around!

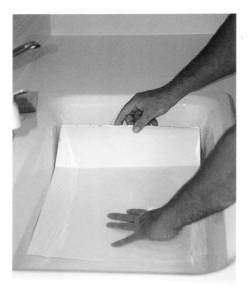

step 1 | **SOAK THE PAPER**

Completely submerge the paper in clean water. Let it soak for a few minutes.

MATERIALS

Your paper

Varnished or shellacked drawing board at least 4" (10cm) bigger than the paper (in each direction)

Sink or water container larger than the paper's dimensions

Sponge

Four pieces of brown paper tape (with water-soluble adhesive, not self-stick), cut at least 2" (5cm) longer than each side of the paper

Paper towels

Thumbtacks or a staple gun (I prefer a staple gun)

Scissors

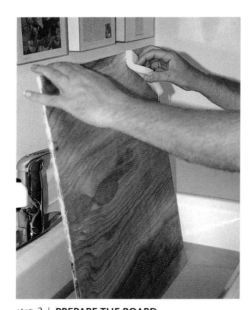

step 2 | **PREPARE THE BOARD**

Sponge over the board so that it is clean and just damp.

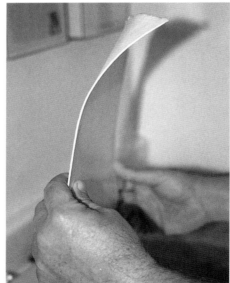

step 3 | **TEST THE PAPER**

Lift the paper part-way out of the water and gently bend one corner over. If the corner snaps back into the original position, it hasn't soaked enough. If the corner stays where you have bent it, as in the illustration, you have soaked it just the right amount! After you have soaked a number of sheets of a given paper, you will know how many minutes to leave it in the water.

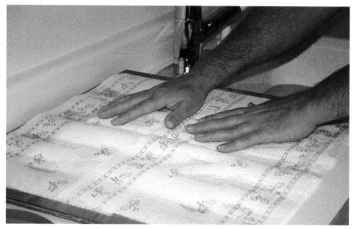

step 4 | **PLACE THE PAPER ON THE BOARD**

Lay the watercolor paper on top of the board. Pat both the board and the paper with paper towels to remove any excess water and to eliminate any bubbles that may have formed. *Don't* rub your watercolor paper. Rubbing will disturb the surface fibers of the paper, and you won't be happy with what happens when you begin to paint on it.

Tape | TIPS

If your tape doesn't stick to the watercolor paper:
- You haven't blotted enough water from the watercolor paper before applying the tape.
- You have washed off too much of the adhesive from the tape before applying it.
- The paper dried unevenly. Perhaps you dried it with the board standing up, or placed it too near a heat source.

If your tape doesn't stick to the board:
- You have not blotted enough water from the board before applying the tape.
- You washed off too much of the adhesive from the tape before it was applied.

Using tacks or staples should also eliminate the above problems.

step 5 | **SECURE THE PAPER TO THE BOARD**

Moisten the glue on the pieces of tape with your sponge. Moisten only one strip at a time, and then apply this strip so that half is on your paper and half is on the board. With a paper towel, run your thumb over the tape (not your paper) to make sure it is firmly attached to both the water-color paper and the board.

Staple (or tack) every two inches (5cm) all around the board. Make sure that the staple goes through the center of the portion of the tape that overlays the watercolor paper. It must penetrate both the tape and the watercolor paper to be effective.

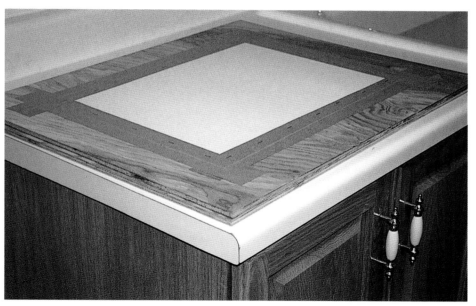

step 6 | **ALLOW THE PAPER TO DRY**

Lay the board flat to dry. Do not place it near a heat source. As the paper dries, it will try to contract but won't be able to since it is held firmly with the tape and staples. After the paper is completely dry, you may begin to paint. Do not remove the paper from the board before you complete your painting. Also, be sure that the finished painting is completely dry before you remove the paper from the board.

You may still have a little buckling in the finished painting, even if you follow these steps or use 300-lb. (640gsm) paper. Flatten your completed paintings by first evenly wetting the back of the painting with a sponge. (Make sure the water doesn't go over the edges and onto your painted surface.) Then sandwich your painting between two drawing boards and place heavy objects on top. Leave this in place overnight or until the painting has thoroughly dried.

The Three Main Techniques

THIS CHAPTER WILL CONCENTRATE on the three main techniques used in transparent watercolor: brush line, the wash and wet-into-wet application. Some painters rely mostly on wet-into-wet work; others may rely mostly on brush line. Most of my work is founded on the wash technique. As you develop your skills, you may find that one of these three techniques will become dominant in your paintings. This will in great measure determine the look of your work.

FORGOTTEN PLACE #7
Linda Stevens Moyer
Transparent watercolor
22" × 30" (56cm × 76cm)
Collection of the artist
Photograph by Gene Ogami

Brush Line

It is important to learn how to use the brush in a sensitive, expressive and economical way. The following exercises will provide you with the opportunity to begin learning how to do this. They will also teach you how to control the brush so that it doesn't control you!

All you need to follow along are a no. 12 or no. 14 round brush, your watercolor paper, a palette with paint and a water container. You may want to try these exercises on less-expensive newsprint first. Placing a sheet underneath the one you are working on will help you control the bleeding of paint.

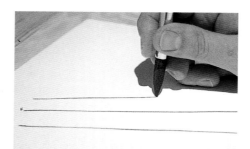

Thin Lines
Mix a large pool of a medium gray paint in your palette using Payne's Gray diluted with water. Hold your brush straight up, perpendicular to the paper, with the bristles barely touching the surface. Keeping your fingers and wrist rigid, move the brush across the paper. This should result in a very thin line. Experiment to see how thin this line can be made. A very thin line can be made even with a large brush.

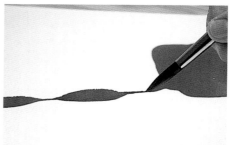

Shapely Lines
You can create shapes as well as lines by varying the pressure on your brush. Hold your brush as you would normally hold a pencil. Drag the brush toward you and alternately apply more and less pressure to the brush. A line that varies from thick to thin should be the result. Experiment to see how thick and how thin you can make a single line. How many times can you go from thick to thin with a fully loaded brush?

Wide Brushstrokes
Now hold your brush so that the handle is parallel to the bottom of the paper. Drag the brush toward you. What kind of a line does this make? How long of a line can you make in this way without reloading your brush? Holding your brush in the position pictured will create a very wide brushstroke.

Rolling Your Brush
Try rolling your brush on the paper. What kind of pattern does this make?

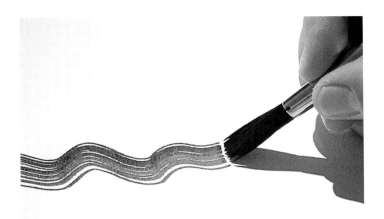

Flatten Your Brush, Take One

After loading your brush, squeeze some of the paint out of the bristles and flatten your brush with your thumb and forefinger. Then drag the resulting "flat" brush toward you. What happens?

Flatten Your Brush, Take Two

Flatten the bristles of your brush again, and then divide them into several groupings. Pull the brush toward you. What kind of mark does this make?

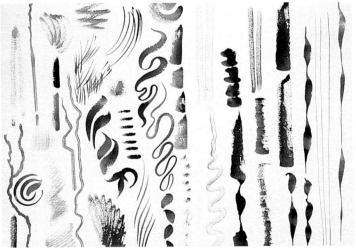

Double-Loading

This illustrates double-loading the brush. First, load your brush with Cadmium Yellow Pale. Next, dip the tip of the brush into a very dark mixture of Payne's Gray and water. Then hold the brush so that the handle is parallel to the lower edge of your paper. When you drag the brush toward you, the resulting stroke will look shaded—in this case, from gray to yellow. You can also triple-load the brush using light, medium and dark mixtures of color.

One Brush, Many Strokes

All of these brushstrokes were done with a no. 14 round. Experiment with as many ways of using the brush as you can invent!

■ assignment #1

Your large round watercolor brush will make many kinds of marks. See how many different kinds of strokes you can make.

Economy of Brushstroke

Because of the transparent nature of watercolor, it is important to learn to apply the medium with as few brushstrokes as possible. Using many overlapping brushstrokes will give a very textured, fussy and perhaps overworked look to your paintings.

Our goal is to create the most expressive shape with every stroke of the brush, resulting in watercolor paintings with the "clean" quality that is so beautiful and unique to the medium. In the next assignment, you will learn how to use your brush economically. You will base your brushstrokes on the silhouettes of leaves and other simple plant forms.

Working on newsprint is good practice in learning to control your brush. Notice that if you hold your brush too long in one spot, the paint will continue to bleed out of the brush onto the paper. Here are some tips for working on newsprint:

- Have several sheets of newsprint stacked on top of each other as you work. If you work on a single sheet the paint will tend to bleed through the paper to the surface underneath.
- If you have too much paint loaded in your brush, it will be difficult to control the shapes that the brush leaves on the newsprint because the paint will continue to spread.
- Transparent watercolor always dries lighter and duller than it looks when you first apply it. Compensate for this by mixing your paint darker and brighter.

■ assignment #2

Gather a variety of leaves and other plant parts that have relatively simple shapes. Look very carefully at the first leaf that you have chosen to paint. Each leaf is different from all others. Try to re-create the entire shape of the leaf (its silhouette) using only one brushstroke. If this is not possible, use two brushstrokes, but not three. If that doesn't work, use three brushstrokes, but not four! Use the absolute minimum of strokes to create each leaf shape.

To get the most out of this exercise, follow these tips:

- Don't draw the shape of the plant form first. The shape should occur only as a result of the economical strokes of your brush. Think in terms of shape, not line—create shapes with your brush!
- The assignment will be easier if the brush is drawn toward you rather than pushed away.
- Do not go back over your brushstrokes. That will cause a streaked look.
- In order to create the shape you want, be aware of what both sides of the brush are doing as you stroke.
- As you work, keep your eyes on the leaf most of the time rather than on your paper. This will help you to more easily record the actual shape of the leaf, not what you think it should look like. Practice will give you confidence and control over the brush.

Try this exercise using a number of different leaves. Paint progressively more difficult shapes using economy of brushstroke.

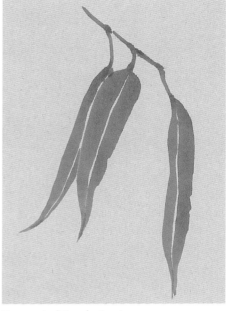

Economical Eucalyptus Leaves
Each of these eucalyptus leaves has been painted with only two brushstrokes. The space between the brushstrokes creates the center vein.

Try Something Different
Try this exercise with various leaves, a different color (like the violet I used in these examples) and watercolor paper instead of newsprint.

What Is Value?

Value is the lightness or darkness of a color. Imagine that you are taking a black-and-white photograph of something. The different grays you see in the finished photographic print correspond to the values of the colors. In transparent watercolor, various values are achieved by adding water rather than by adding white.

A watercolorist must learn to simplify without losing the essence of the subject. Practice the following value exercise several times by using progressively more difficult plant forms (for example, several leaves on a branch, or flowers). As you gain more experience, your brushwork will become better and you will also be able to better recognize and simplify the values in your work.

Start With the Lightest Value
Beginning with the lightest value, paint the entire shape of the leaf, only leaving the paper white where there are highlights. Use as few brush-strokes as possible for each shape you paint. Allow the paint to dry thoroughly before going on to the next step. You may use a hand-held hair dryer to dry your paint.

Add the Medium Value
Now look at your leaf carefully. Where are the middle and dark values? Paint those shapes with the medium value of paint that you have mixed, using economical brushstrokes. Those shapes will overlap parts of the lightest value you applied in the previous step. Dry the paper thoroughly.

Finish With the Darkest Value
Last, look for the darkest values. Paint these shapes carefully using your brush economically. Applying the darkest value completes the painting. The result should be a leaf that has convincing light and form.

The Wash

Perhaps the most important technique in watercolor is the wash. Most of your work will involve applications of various kinds of washes to the surface of your paper. A wash is simply wet paint applied to the surface of dry paper in an area larger than can be painted by a single brushstroke.

There are two types of washes: the flat wash and the gradated wash. We will begin with the flat wash.

Step 1

A wash is started at the top of the desired shape. Paint a horizontal stroke with a fully loaded brush near the top of your paper. Be sure that you have loaded your brush enough so that a generous bead of paint will be left at the bottom of the stroke.

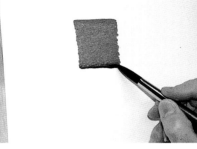

Step 2

Dip your brush back into the mixed paint and immediately paint another horizontal stroke that partly overlaps the bottom of the first stroke. The excess paint from each stroke should continue to collect in a bead at the bottom of the shape you are creating. Continue reloading your brush after each stroke, overlapping horizontal strokes and allowing the paint to puddle at the bottom. Gravity is your ally in blending the different strokes as it gradually pulls the paint down.

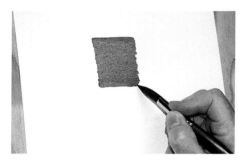

Step 3

When your shape is complete, rinse the brush and squeeze it gently. Use your brush as a "sponge" to remove the remaining bead of paint at the bottom of your completed wash. Be sure that your brush is not too wet when you do this or you will get a backwash—the wet portion will bleed back into the drier part, ruining your smooth, flat wash. I usually dry the completed shape with a hand-held hair dryer to avoid this.

Notice that the shape of the wash has a definite boundary. This is called a hard edge.

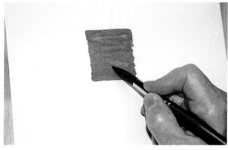

Warning!

Don't go back over the wash with your paintbrush. This will create streaks.

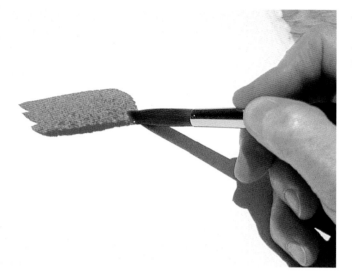

assignment #5

Your objective in painting a gradated wash is to create a gradual change of value from the top of the shape to the bottom. You will follow much the same procedure as you did to create the flat wash. Start with a medium-value mixture of any of your darker pigments. Mix enough of this value to cover an area at least 3" x 3" (8cm x 8cm).

Step 1

Paint a horizontal stroke near the top of your paper with a fully loaded brush.

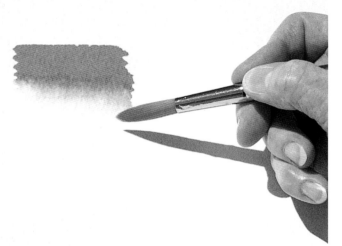

Step 2

Dip your brush into clean water and immediately paint another horizontal stroke partly overlapping the first stroke. Repeat this process, continuing to dip your brush back into the clear water before each stroke. As in the flat wash, the excess paint from each stroke will collect at the bottom of the shape you are creating.

It is important to work as quickly as possible or the strokes of water may bleed back into the color that you've added and cause the backwash effect that is seen in this step.

Shape | TIP

It is easier to create a specific shape if you define the edges of that shape with the brush as you work through the wash sequence.

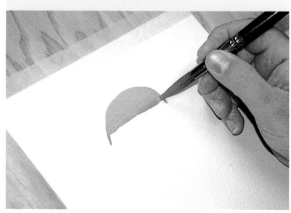

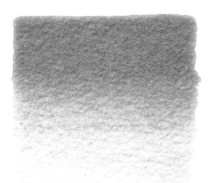

Finished Wash

As the painted area continues down the surface of the paper, the paint is progressively more diluted with clean water and the value becomes lighter.

■ *assignment #6*

You can also create a graduated wash by using two colors rather than one color with clear water. This will create a transition from one color at the top of the shape to the other color at the bottom of the shape. Make sure you have adequate pools of each color mixed before you begin this assignment.

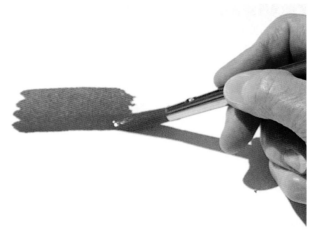

Step 1

Begin at the top of your shape with one color, using overlapping strokes as you did when creating the one-color gradated wash.

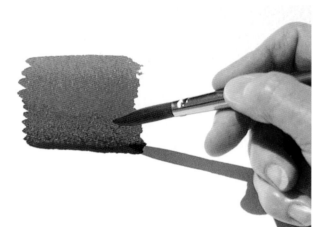

Step 2

As the gradated wash progresses, instead of dipping your brush into clean water, dip your brush into the second color. Apply it in overlapping strokes as you continue down the paper. Be sure that you have enough paint on your brush to maintain an excess bead of color. Do *not* wash your brush between strokes!

Finished Wash

The objective of this technique is to create a smooth, gradual change across a shape.

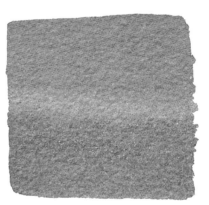

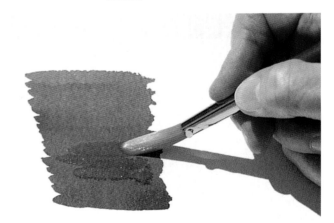

Warning!

Take care not to go back over previous brushstrokes, as this will make streaks and waterspots in what should be a very clean transition from one color to another.

LAYERING WASHES

Layering washes may also be referred to as "stacking" washes or *glazing*. In this process, transparent washes are layered on top of each other to create a full range of values and colors in the finished watercolor painting. Each layer of color must dry completely before layering on the next.

In transparent watercolor, it is traditional to work from light to dark, applying the lightest washes first and painting progressively darker washes until the painting is completed. Under most conditions, a painting progresses from large general areas of light washes to small specific areas of dark washes. Reversing the value order may result in edges bleeding from the dark areas into the lighter ones. It may also be more difficult to remember to save the lighter values needed in the finished painting. Because of the transparency of this medium, the artist generally cannot paint lighter or white areas at the completion of the painting. These white or lighter shapes must be carefully planned for and saved at the beginning.

In this demonstration, three values of washes were used to paint a group of leaves. Frequently stir the different mixtures as you use them in the steps. Otherwise, pigments that contain sediment will tend to settle to the bottom of your mixture, and you will not be able to get washes that are consistent in value.

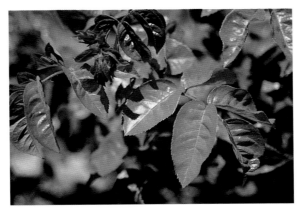

Reference Photo

Work With Three Values
Create a light, medium and dark value of Payne's Gray by gradually diluting the color with more water. Test your three values on a separate piece of paper to make sure that they are evenly distributed from light to dark.

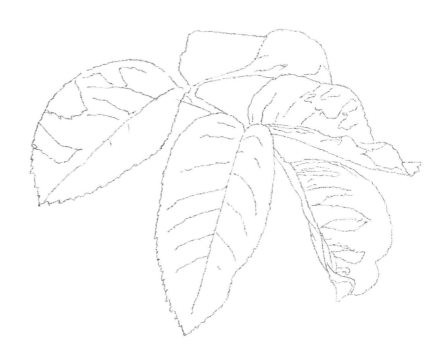

step 1 | **MAKE A DRAWING**
Draw selected leaves lightly on your watercolor paper, using a no. 2 or HB drawing pencil.

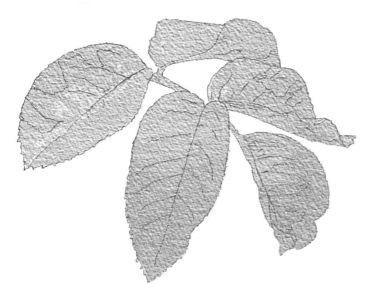

step 2 | SAVE WHITE AREAS AND APPLY THE LIGHTEST WASH

Determine where the light is most strongly reflected from the leaves. Where the light is very intense, leave these areas as the white of the paper. It is important to be aware of the shapes that are to remain white so that they are not lost in the subsequent steps. Sometimes it is helpful to draw in these shapes before you begin painting.

Once you've decided what areas to save, apply a flat wash to all of the rest of the subject with the lightest of the three values. Make sure the paint is completely dry, using a hair dryer if desired, before moving on to the next step.

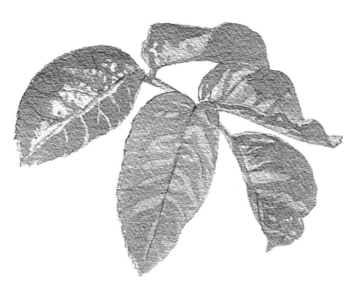

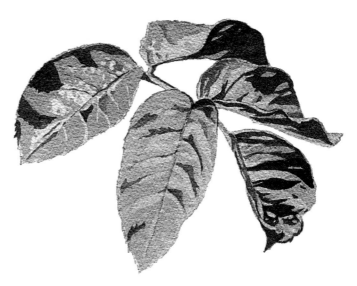

step 3 | APPLY THE MEDIUM-VALUE WASH

Study the reference photo to determine where the values of the subject are darker than the value of the light wash you just applied. Paint these darker shapes with the medium value. Only parts of the light value will be layered with the medium value. Let this layer dry before continuing.

step 4 | APPLY THE DARK-VALUE WASH

Now apply the darkest value, using the reference photo to see where the darkest shapes are.

USING MASKING FLUID

Art masking fluid may be used to save the white of the paper. This is especially helpful if the shapes to be saved are quite small.

Masking | TIPS

- Wash out your brush a number of times while applying the masking fluid so that the fluid doesn't dry in the brush while you're working. If it dries, the brush will be ruined. Each time you clean your brush, dip it in clear water and then rub it on a bar of hand soap until it is slightly soapy.
- Use a separate water container for washing out the brushes you use for masking. Don't let masking fluid come into contact with your good painting brushes.
- Masking fluid leaves a very distinctive hard-edged shape in the finished painting. For this reason, I use masking only on small shapes that would be very difficult to paint around. Some artists use a damp, stiff-bristle brush to soften the shapes left by masking.

step 1 | APPLY SOAP TO THE BRUSH

Use an inexpensive brush that comes to a good point. Dip the brush in clear water and then rub it on a bar of hand soap until it is slightly soapy. (This will make it easier to wash the masking out of your brush.)

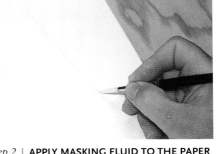

step 2 | APPLY MASKING FLUID TO THE PAPER

Dip your brush into the masking fluid and paint the shapes you wish to save as the white of the paper. Be sure that the masking fluid is completely dry before you go on to the next step. You may use a hair dryer for this.

step 3 | APPLY PAINT

Apply a wash of color over and around the area that has been masked, and let the paper dry.

step 4 | REMOVE THE MASKING

Once the paint is completely dry, remove the masking with a rubber cement pickup or by rubbing your finger over the surface.

Finished Result

The white of the paper has been retained in the areas where the masking was applied.

■ assignment #7

Set up a still life or a single subject, illuminated with a strong light. Paint the still life using layered washes of three values of one color, plus the white of the watercolor paper as your lightest value. Mix enough of each of the values so that it won't be necessary for you to mix more of a particular value during the course of the painting.

Set up another still life and use four or five different values of one color to paint it. You may wish to use masking to save your whites.

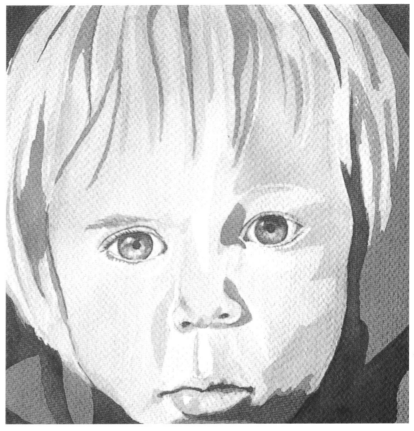

Value Study

This artist completed assignment 7 using a face as her subject.

A Boy's Face
Transparent watercolor
Valerie Lloyd
14" × 14" (36cm × 36cm)

Softening Edges | TIP

A hard-edged wash may be softened by dragging a clean, wet brush down the edge while the wash is still wet. The color from the wash will bleed out into the newly moistened area and create a soft edge. Dry this immediately. Caution: If the brush is too wet, the water will flow back into your wash.

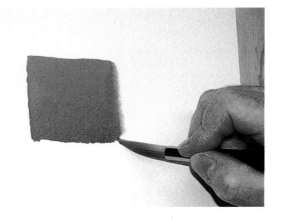

Wet-Into-Wet

The third main technique used in transparent watercolor painting is called *wet-into-wet*. In this technique, water is applied to an area of the paper and then paint is brushed on, creating soft-edged shapes that flow within the previously moistened area.

This is the most difficult of the techniques to control, as the paint will continue to move on the wet surface of the paper unless it is immediately dried.

The wet-into-wet technique is especially useful if you are painting a large area. Sometimes a wash will dry too quickly to fill in a large shape evenly. Wetting the paper first and then applying the paint will help you smoothly cover a large portion of the paper.

Different Colors Spread Differently
The wet-into-wet technique is most successful if the paint is applied with as few brushstrokes as possible. Try this exercise: Use a large flat brush to wet the surface of a piece of watercolor paper. Then, apply different colors to the surface. The colors will spread at different rates. Try various brushstrokes to see what happens.

Color TIP

Watercolor paint will generally dry lighter and less intense than it appears when wet. When working wet-into-wet, the water that is applied to the paper first will dilute the colors of the paint. Compensate for this by mixing colors that are darker in value and more intense in color than you would mix for working on dry paper.

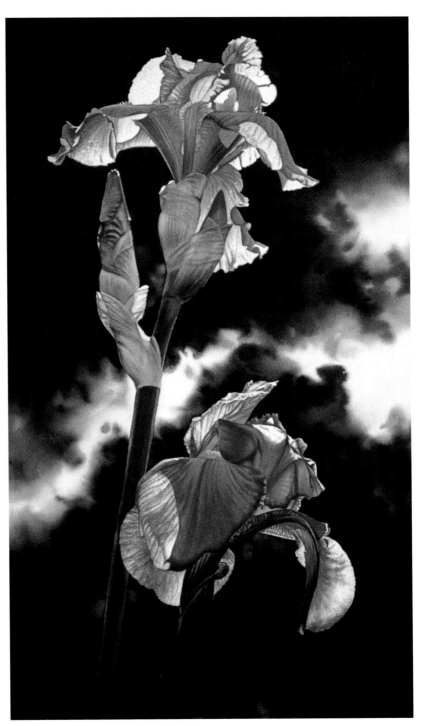

The dark shapes of the clouds behind the iris were created by using the wet-into-wet technique.

IRIS #6
Linda Stevens Moyer
Transparent watercolor
42" × 29¹/₂" (107cm × 75cm)
Collection of Gary and Brenda Daitch

USING THE THREE TECHNIQUES TOGETHER

You now know the three main techniques of transparent watercolor and have had some practice with each of them. These techniques are commonly used together. Washes may be layered over wet-into-wet areas that have dried, and vice-versa. Brushwork can be layered over the other techniques as well.

See how the three techniques are used together in the following demonstration.

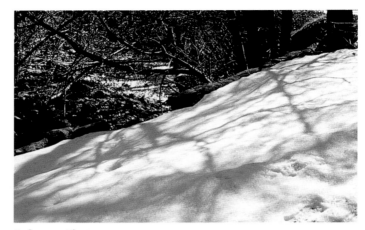

Reference Photo

MATERIALS

300-lb. (640gsm) rough water-color paper, 20" x 30" (51cm x 76cm)

Light pencil

Masking fluid

Salt

No. 14 round brush

Watercolors

- Alizarin Crimson
- Burnt Sienna
- Phthalo Green
- Ultramarine Blue
- Yellow Ochre

step 1 | **MAKE A DRAWING AND TINT THE PAPER**

I used just a few lines to sketch the composition. Because I was mostly interested in the light in the snow—and to make a more effective composition—I raised the level of the snow. Then, using the wet-into-wet technique, I tinted the entire piece of watercolor paper with a mixture of Yellow Ochre and Alizarin Crimson. In this process, I applied more Alizarin Crimson near the bottom of the painting. I wanted the snow to have a warm glow to it. Because we are working in *transparent* watercolor, the initial tinting of the surface influences all of the other colors that are layered on top of it. I then dried the surface thoroughly with a hair dryer.

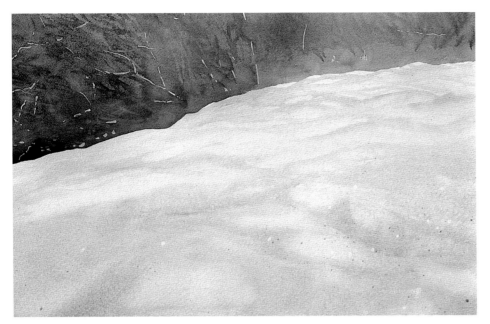

step 2 | APPLY MASKING AND USE THE WET-INTO-WET TECHNIQUE

A toothbrush was used to spatter masking fluid on portions of the composition where I wanted the snow to glisten. I also used masking fluid to save light areas in the upper section of the trees. I then began to develop some of the forms and shadows in the snow and tree areas primarily by using the wet-into-wet technique. The darker background was mixed with different proportions of Ultramarine Blue, Phthalo Green, Alizarin Crimson and Burnt Sienna.

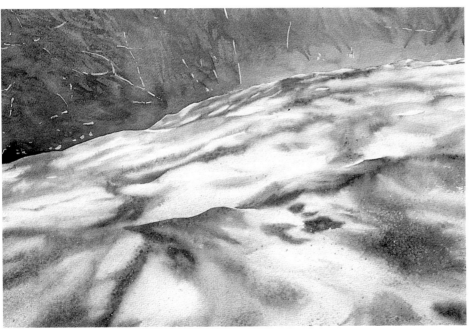

step 3 | APPLY SOFT-EDGED WASHES AND SALT

I continued to work on the forms and shadows in the snow with layered soft-edged washes, using different mixtures of Ultramarine Blue, Phthalo Green, Alizarin Crimson and Burnt Sienna. As the values became darker in the painting, the contrast made the snow look lighter. I also used salt sprinkled on some of the painted areas to create textures in the snow. The salt was sprinkled on wet paint and allowed to dry naturally. When the paper was completely dry, the salt was brushed off. The effect of the salt can be seen especially in the lower-right corner of the painting.

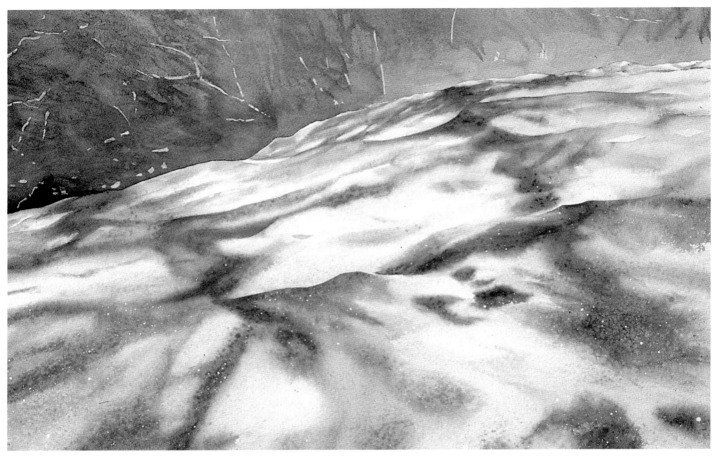

step 4 | **LAYER THE DARKER WASHES**

At first glance it may be difficult to see much change between steps 3 and 4. Actually, several hours were involved in continuing to develop the forms of the snow surfaces and the cast shadows across the snow, using dark, dull colors mixed from my palette. Alizarin Crimson and Burnt Sienna were used to dull the cooler colors. After I was certain that the paint was completely dry, I removed the masking in the snow area, revealing sparkles on the snow.

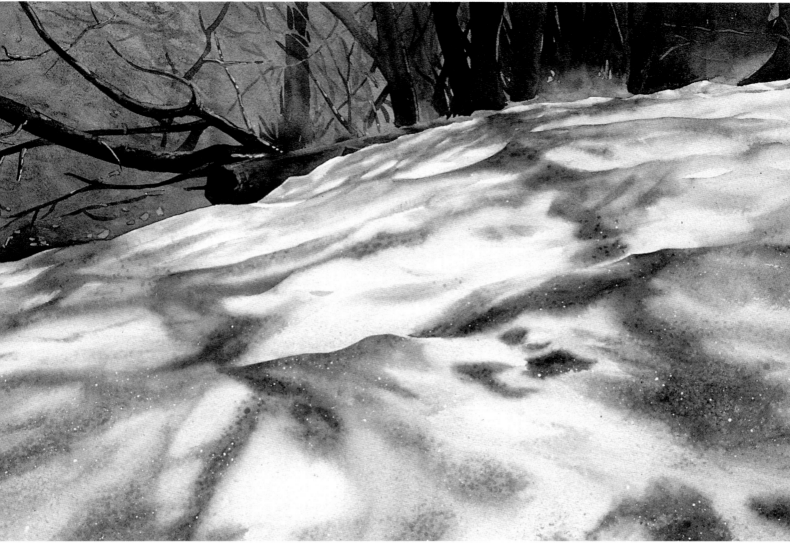

step 5 | **FINISH WITH THE BRUSH LINE TECHNIQUE**

The brush line technique was used in the upper section to develop the trees. When the masking fluid was removed from this area, the saved portions of the paper appeared to be too light. I tinted them with a mixture of Alizarin Crimson and Yellow Ochre to make them glow with the same kind of light that appears in the snow.

WINTER LIGHT #1
Linda Stevens Moyer
Transparent watercolor
22" × 30" (56cm × 76cm)
Collection of Home Savings of America, California

Simple Color Theory That Works

THERE ARE MYRIAD THEORIES AND books about color for the painter. Many of them are quite complex, but I don't believe that color theory has to be complicated. This chapter will provide a review of color facts. Most of this information will not be new to you. It may, possibly, be presented in a different way than you have previously learned. The information is designed to help you to be a colorist: an artist that understands how to use color while painting. I hope that this chapter will take the mystery out of how to mix paints and reinforce your confidence in using color.

FEATHER LIGHT #1
Linda Stevens Moyer
Transparent watercolor
53¹/₂" × 79" (136cm × 201cm)
Collection of the artist
Photograph by Gene Ogami

Describing Color

My use of color is based on the traditional twelve-step color wheel. Red, blue, and yellow are the three *primary* colors that are used to make all of the other colors on the wheel. These three colors cannot be created by mixing other colors.

The *secondary* colors are created by combining an equal *color weight* of two of the primary colors. Each of the pigments on your palette has a different *color weight*. By that, I mean strength of mixing power, not equal quantities. You will find that perhaps you may need more of one color than another when trying to mix the color that visually lies between them.

A lot will depend on how you visualize each color; for example, how do you visualize a middle-of-the-road green? When mixing the secondary color of green, you will mix blue and yellow until it resembles that ideal green. Mixing an equal color weight of red and yellow creates orange. Blue and red mixed together create violet.

The *tertiary* or intermediate colors are created by mixing an equal color weight of a primary and a secondary color that are next to each other on the color wheel. The names of the colors are hyphenated words with the name of the primary color coming first, followed by the name of the secondary color (i.e. yellow-orange, blue-green, etc.).

Color Vocabulary

WHAT ARE TINTS?

Tints are colors plus white. In transparent watercolor, the white of the paper becomes the white of the medium. In order to make a tint of a color, we add water to the pigment, allowing the white of the paper to come through the transparent color. The more water that is added, the lighter the tint of the color will be.

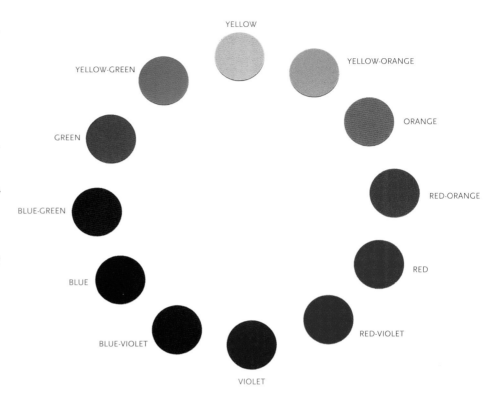

ORIGINAL COLOR + WATER = TINT ORIGINAL COLOR + BLACK = SHADE

WHAT IS A SHADE?

A shade is a color plus black. The more black that is added to a color, the darker the shade will be.

WHAT ARE WARM COLORS?

The warm colors on the color wheel are yellow, yellow-orange, orange, red-orange and red. They have the spatial property of coming forward in a composition. This is just one of many color-related facts that will help you create the illusion of space in your work.

WHAT ARE COOL COLORS?

The cool colors are violet, blue-violet, blue, blue-green and green. They recede spatially.

WHAT ARE BORDERLINE COLORS?

Red-violet and yellow-green are borderline colors. They each contain a warm and a cool color. so they can't be placed in the warm or cool color categories.

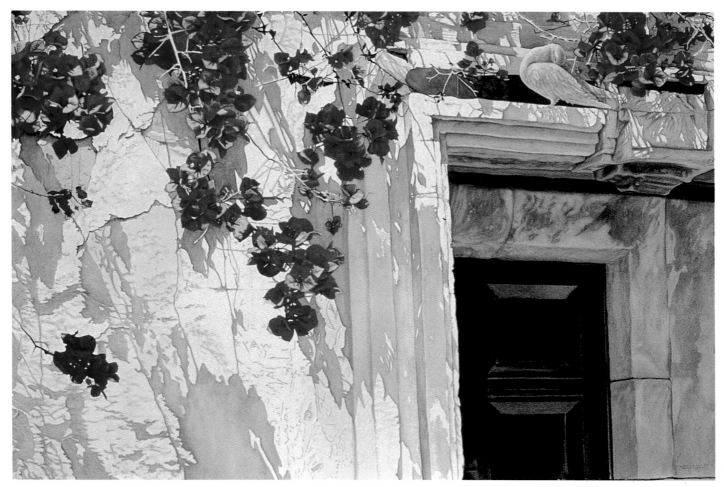

Warm-Color Dominance

Most of the colors in this painting are warm. Even some of the shadows have pink in them. The doorway is recessed and makes use of cool browns in areas to place it back in space.

FEATHER LIGHT #6
Linda Stevens Moyer
Transparent watercolor
40" × 60" (102cm × 152cm)
Collection of Dr. and Mrs. David
Tonnemacher, Glendale, California
Photograph by Gene Ogami

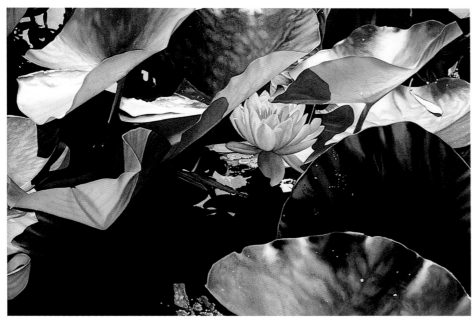

Cool-Color Dominance

The majority of the colors in this watercolor are cool. The small amounts of warm colors on the edges of the leaves and the water lily blossom intensify the effect of the greens.

HAIKU #18
Linda Stevens Moyer
Transparent watercolor
29¹⁄₂" × 42" (75cm × 107cm)
Collection of Dr. and Mrs. David
Tonnemacher, Glendale, California

Analogous Colors

The colors that are next to each other on the color wheel are called *analogous* colors. For example, yellow-orange, orange and red-orange are analogous colors. Because analogous colors are all related to each other—they all have at least one color in common—they are easy to use in a composition.

La Jolla Cove #6 is based on an analogous color scheme of blue, blue-violet, violet and red-violet.

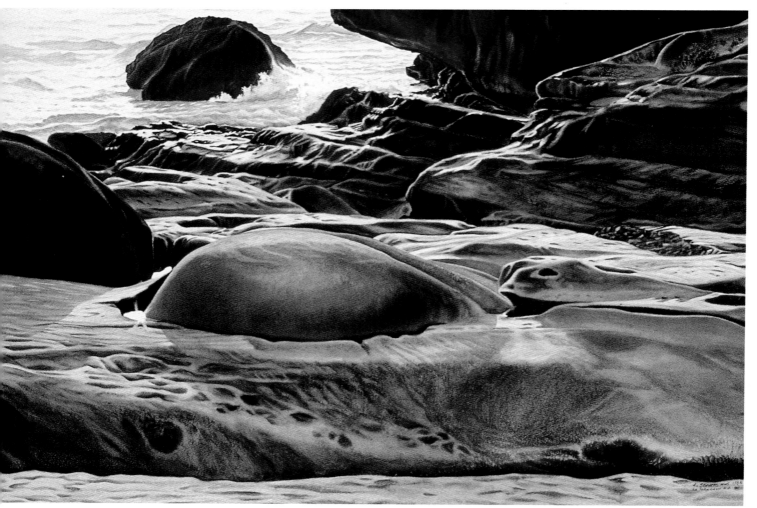

LA JOLLA COVE #6
Linda Stevens Moyer
Transparent watercolor
$29^{1}/_{2}" \times 42"$ *(75cm × 107cm)*
Collection of National Bank of La Jolla, California

Complementary Colors

Complementary colors are two colors that are positioned opposite each other on the color wheel (red and green, blue and orange, yellow-orange and blue-violet, etc.). It is essential that the painter knows all of the complementary colors on the color wheel and how to use them to effectively mix the colors that are wanted in a composition.

Complementary colors (blues and oranges) were used to develop *Carolanne*.

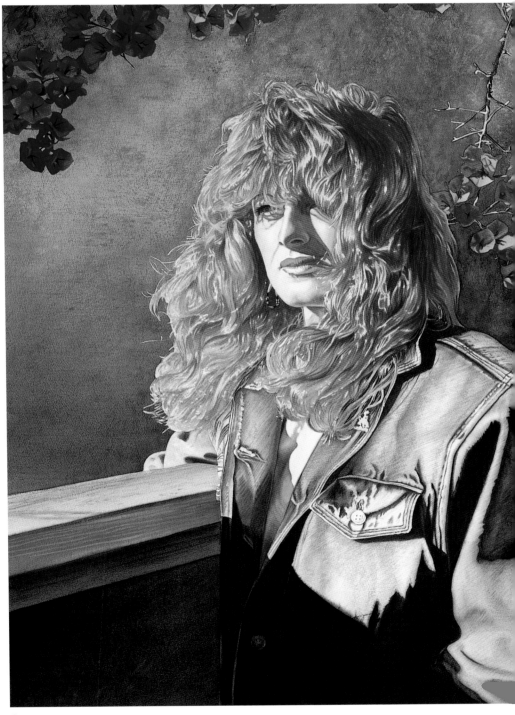

Carolanne
Linda Stevens Moyer
Transparent watercolor
42" × 29¹⁄₂" (107cm × 75cm)
Collection of Carolanne and Marc Pange, Palm Springs, California

An Easy Way to Learn the Complements

If you are a beginning painter, this may seem somewhat daunting at first, but there is an easy way to learn them. All you must memorize is three pairs of complementary colors. If you use association, it's very easy. You could relate the names of the three pairs of complementary colors to holidays or really anything that helps you to remember. (My husband would probably choose football teams.)

For example: we could say that red and green are Christmas colors; yellow and violet could be Easter colors; blue and orange might be Thanksgiving colors. That's easy, isn't it?

All of the other pairs of complementary colors on the color wheel can be figured out by using the above three pairs. For example, without looking at the color wheel, what is the complementary color of blue-green? Blue is one of the Thanksgiving colors. The other Thanksgiving color (and blue's complement) is orange. Green is one of the Christmas colors. The other (and green's complement) is red. The complement of blue-green is red-orange.

Why did I put red first in naming the complement of blue-green? Because red is a primary color, and the name of the primary color is always listed first when naming the tertiary color.

Let's try that again. What is the complementary color of red-violet? Without looking at the color wheel! Red is one of the Christmas colors. Its complement is green. Violet is one of the Easter colors. Its complement is yellow. If we put these two complements together and place the primary color first, we have yellow-green—the complement of red-violet.

Complementary Colors Complete Each Other

You should also know that complementary colors complete each other on the color wheel. For instance, if we took all of the yellow out of the color wheel, we

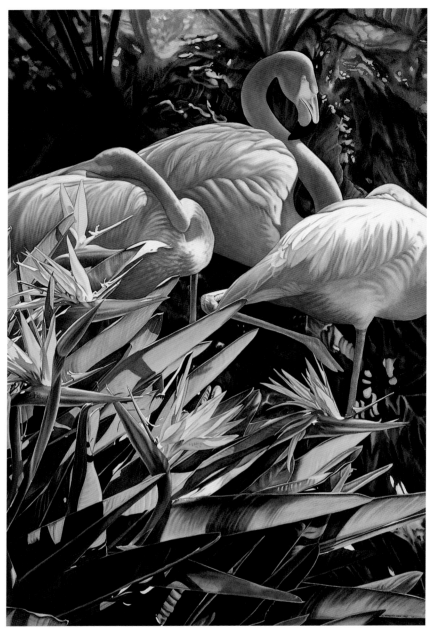

Complementary Colors Should Not Compete
This painting is based on a color scheme of blue and blue-green with their complements, orange and red-orange. The tints of red complement the greens used. When using complementary colors in a composition, it is important that one of the colors be dominant. Here, the cool colors dominate.

FEATHER LIGHT #12
Linda Stevens Moyer
Transparent watercolor
60" × 40" (152cm × 102cm)
Collection of Mr. and Mrs.
Joe Harch, Palm Beach,
Florida

would only have violet left. How does this work? Well, red, yellow and blue make all of the colors on the color wheel. If we remove yellow, all we have left is red and blue, which make violet—the complement of yellow. If you took all of the orange out of the color wheel, what color would be left?

The Three Properties of Color

As an artist it is important to understand and to be able to use the properties of color: hue, value and intensity (or chroma).

The *hue* of a color is the name of the color, or the color of the color (for example, Cadmium Orange is an orange hue). The hue is determined by the wavelength of light that is reflected from an object back into the viewer's eyes (see sidebar).

Value is the darkness or lightness of a color. *Intensity*, or chroma, is the brightness or dullness of a color. The intensity of a color is equivalent to the saturation or purity of the color.

Most artists recognize and use the first two properties quite successfully in their work. It is the third property, intensity, that separates the novice from the sophisticated painter.

How Do We See Color?

Sunlight is a mixture of many different wavelengths. Some are visible and some are not. We see the wavelengths of light that are reflected into our eyes.

If we see a red object, only the wavelengths that represent the red part of the spectrum are reflected back from the object into our eyes. The remaining light is absorbed by the object.

If the object appears to be white, then we know that the entire visible spectrum is being evenly reflected back to us, and little of the light is absorbed by the object. Conversely, a black object evenly absorbs most of the visible spectrum and returns little of the light to our eyes.

Color Values Compared With Gray
In this illustration, the colors are paired with grays that are the same value. The equivalent values of colors are easier to see if you squint your eyes when you look at them.

These two colors are the same value.

Mix Complementary Colors to Decrease Intensity
You can make a color duller by adding its complement. This is also called "graying" a color (although you do *not* add gray) or decreasing its chroma or intensity. In this example, red-violet and yellow-green are the complements. When they are mixed together in different quantities, various dull red-violets and yellow-greens are the result.

Intensity May Be the Key to a Color

Some colors cannot be mixed without understanding how to change the intensity of the color. An example of this is navy blue. Let's examine this color in terms of its three properties. The hue is, obviously, blue. The value is quite dark. The intensity (or chroma) is dull. In order to obtain this intensity, the complementary color of blue must be mixed with it. Or, in other words, orange must be mixed with the blue to dull it.

■ *assignment #8*

Dull a color by mixing it with a small amount of its complement.

Know Your True Colors

It is important to understand the color composition of each particular tube of paint in order to use it effectively. Much of this understanding has to do with seeing. For example, my ideal orange would match the color of a ripe navel orange. This gives me a reference point and I mentally compare all other oranges with this to determine what additional colors may be in a particular tube of paint. I do this with all of the colors on my palette. Phthalo Green is not a middle-of-the-road green to my eyes; it contains a lot of blue. This knowledge enables me to use the color successfully when mixing it with other colors on my palette.

Once, I received a call from an artist who was trying to mix violet. She said, "I am mixing blue and red together because I know that will make violet, but it's not working! What's wrong?" She then told me that she was using Cadmium Red and Cerulean Blue. Each of these colors contains yellow. Unwittingly, she was adding the complement of violet (yellow), which dulled the mix and resulted in a very gray, muddy-looking violet.

To mix a satisfactory violet, she had to select red and blue pigments that don't contain yellow. I advised her to use Alizarin Crimson and Ultramarine Blue.

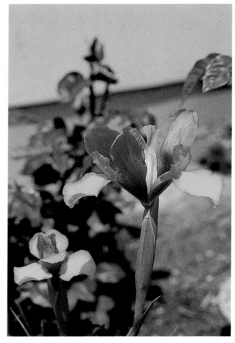

Nature's Complements

Notice how complements mix in nature. In this iris, the yellow and violet have mixed to create dull violets and dull yellows.

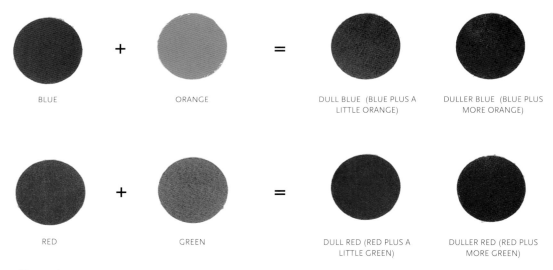

| BLUE | + | ORANGE | = | DULL BLUE (BLUE PLUS A LITTLE ORANGE) | DULLER BLUE (BLUE PLUS MORE ORANGE) |

| RED | + | GREEN | = | DULL RED (RED PLUS A LITTLE GREEN) | DULLER RED (RED PLUS MORE GREEN) |

Dulling Colors

The top example shows two dull blues made by mixing varying amounts of Cadmium Orange with Ultramarine Blue. I used Phthalo Green to dull Alizarin Crimson in the bottom example. Adding more of a complement to a color will dull it more.

Mixing Black

I don't have black on my palette. There are many different blacks in nature, and if only one black is used in painting, the color range and the effectiveness of color are limited. You will want to mix your blacks in different ways to reflect the different colors of black that you see.

When we mix paint, we use a subtractive process. When we mix complementary colors we are, in effect, blocking the return of some of the wavelengths of light to the viewer's eye. For example, if we mix a little green with red, we neutralize (or block or subtract) some of the red. We change the mixture so that not all of the red light is allowed to return to the viewer's eyes. This makes the red look duller.

Earlier in the chapter we learned that complements complete each other. Red and green complete each other on the color wheel. If we mix an equal color weight of green and red together, this mixture doesn't allow the return of either color to our eyes. The red wavelength of light blocks the green and vice-versa, and we should see black.

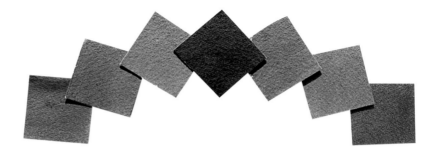

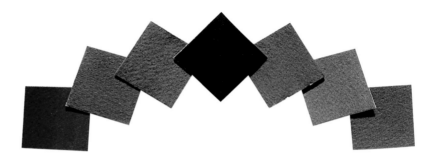

Different Ways of Mixing Black
Artists have their own favorite ways of creating black. In the top example, French Ultramarine Blue and Burnt Sienna were used to mix black. The bottom example shows how Prussian Blue and Light Red will make an effective black. In both cases, complements were used: Burnt Sienna representing a dull orange (the complement of blue), and Light Red representing a dull red-orange (complementary to the blue-green of the Prussian Blue). (Art created by E. Duain Jewett)

How Many Ways Can You Mix Black?

Mixing equal color weights of two complements is one way of mixing black, but there are other ways. Remember, you are trying to block the return of any wavelength of light to the viewer's eye. You can:

- Mix all of the colors on the color wheel together in equal color weights.
- Mix the three primary colors together in equal color weights.
- Mix the three secondary colors together in equal color weights.
- Mix the six tertiary colors together in equal color weights.

Or…

- You could mix two complementary colors together in equal color weights. This is certainly the easiest of the five!

In these examples, you are really mixing all of the colors on the color wheel together, allowing them to block the return of light to the viewer's eye. In order to achieve results with any of these combinations, the colors must be true pigments (true primaries, secondaries and tertiaries).

The pigments available in most color brands do not include true primaries, secondaries or tertiaries. My palette doesn't have a true red, blue or green. I have two reds: a warm red (one that has yellow in it) and a cool red (one that has blue in it).

■ *assignment #9*

Set up a still life of all black objects against a black cloth. Light the still life. Zoom in to focus on just a part of the still life, and, using the techniques that you have learned, paint the scene on at least a half sheet of watercolor paper. This will help you discover the nuances of black.

When mixing one of these reds with another color, I must keep in mind the color bias (or additional color) that the pigment contains. I also have two blues: a warm blue and a cool blue. Phthalo Green has quite a bit of blue in it, so if I need a "true" green, I must mix some yellow with this pigment.

Where Is Brown on the Color Wheel?

Browns are created by adding the corresponding complements to the various hues on the color wheel to decrease their intensity. Just as there are many blacks, there are also many browns. The difference between using complements to mix blacks and to mix browns is the proportions of the complements used. When mixing blacks, an equal color weight of each of the complements is used. When mixing browns, an unequal color weight of the complements is used.

Some browns are warm browns that have been created by dulling warm colors with their complements. Others are cool browns that were mixed by dulling cool colors with their complements.

■ *assignment #10*

Mix a black by mixing equal amounts of two complementary colors. Next, try mixing a brown using those same complements, only in *unequal* amounts.

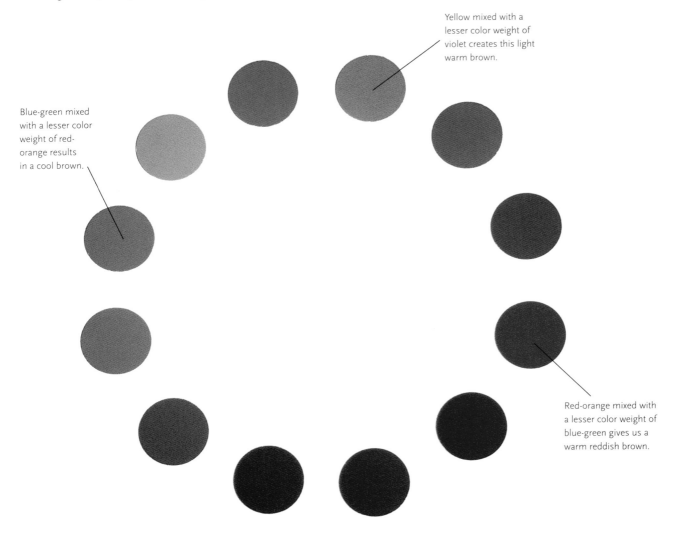

Yellow mixed with a lesser color weight of violet creates this light warm brown.

Blue-green mixed with a lesser color weight of red-orange results in a cool brown.

Red-orange mixed with a lesser color weight of blue-green gives us a warm reddish brown.

Warm Browns, Cool Browns
These are just some of the many browns that can be mixed from complementary colors.

Alternative Primary Triads

Substituting different versions of red, yellow and blue to create alternative primary triads will help you practice what you know about color mixing and become more aware of color relationships.

■ *assignment #11*

Create an alternative primary triad color wheel. Here's how:

1. Draw a color wheel template.
2. Using an alternative primary triad—Burnt Sienna, Yellow Ochre and Payne's Gray—mix all of the colors on the wheel. Mix a fairly large quantity of each color on your palette.
3. You can make the colors appear more intense (brighter) by painting a ring around each that consists of its dull complement. Juxtaposing colors in this way is one of the tools you can use to change the appearance of colors in your compositions.

EXAMPLE: For one of the center circles you will create orange by mixing an equal color weight of Burnt Sienna and Yellow Ochre (your red and yellow substitutes). Try to create a color that is exactly between those two colors visually—think of a navel orange. Then, paint a ring around the orange by mixing blue (Payne's Gray with water) and dulling it with a little of the orange you have just mixed. This should make the orange circle look much more intense (more orange). Be careful not to add too much orange or the mixture will turn to a dull orange rather than staying a dull blue!

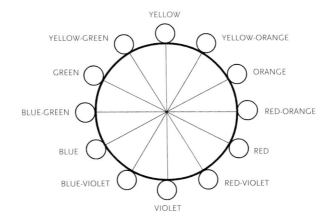

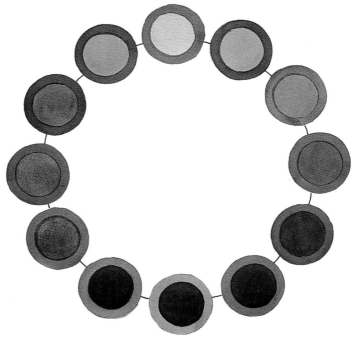

Begin With a Color Wheel Template

Your template doesn't have to be perfect (or even very neat!). Notice that there are twelve small circles on the wheel, representing the colors on the traditional color wheel. It will help you if you label where each color will go before you begin painting.

One Possibility

Your alternative triad color wheel might look something like this.

Alternative Triad | TIPS

- Test your colors on a separate piece of paper as you mix them.
- Make sure that you clean your brush thoroughly between colors. Just a small amount of the wrong color will throw your mixture off. It is also very important to keep refilling your water container with clean water.

- Mix a tint of Yellow Ochre to get a yellow that looks really yellow. You will also want to add quite a lot of water to your Payne's Gray to get a mixture that will look very blue.
- Burnt Sienna will look redder if there isn't too much water added to it.
- Mixing the violet and blue-violet will be the most difficult, so don't worry if you're having trouble.

Alternative Primary Triad Painting

As I worked on the *Water Light* series of paintings, I noticed that I constantly had to replace three colors: Burnt Sienna, Yellow Ochre and Ultramarine Blue. I realized that, unwittingly, I had been basing my compositions on an alternative primary triad system.

WATER LIGHT #29
Linda Stevens Moyer
Transparent watercolor
40" × 60" (102cm × 152cm)
Collection of Peggy Hannawell, Anaheim, California

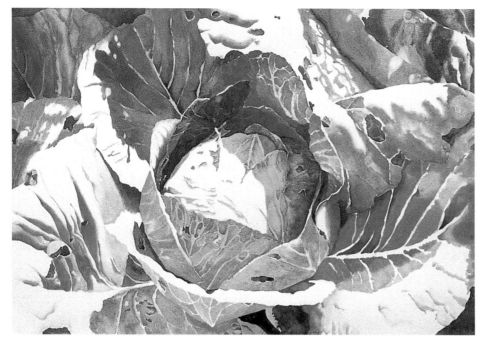

Another Alternative Primary Triad
This entire painting was done with another alternative primary triad. Only three tubes of paint were used: Winsor & Newton's Manganese Blue, Aureolin and Scarlet Lake.

CABBAGE
Nedra Tornay
Transparent watercolor on 300-lb.
(640gsm) rough watercolor paper
22" × 30" (56cm × 76cm)

■ *assignment #12*

Paint a still life using an alternative primary triad. Use a page from a comic book or the comics section of the newspaper and three brightly colored crayons. (The idea is to have still-life objects that are brightly colored.) Manipulate those materials in any way you wish. Crumple the paper and place the crayons on it or incorporate the image of the crayons into your drawing in some way. Use your imagination!

Follow these instructions:
- Draw your composition on a piece of watercolor paper.
- When painting, only use watercolor; don't draw with the crayons. They are only for your still-life setup.
- Create your painting using only the alternative primary triad from the last assignment to mix the various colors that you need for your composition.
- Use the three main techniques of transparent watercolor and what you know about mixing and juxtaposing colors to create the most intense colors you can.
- Use your no. 14 brush whenever possible. Remember, this brush can paint even the smallest shapes and lines. This will help you develop a habit of using your brush economically to produce clean, beautiful watercolor paintings.

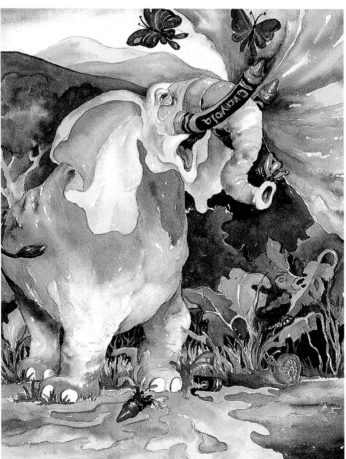

Completed Assignment
In this example, the artist took more liberties. She not only incorporated crayons into the subject matter of the cartoon but she also added other elements as well. Many different colors were mixed from the three alternative primaries used.

ELEPHANT
Ruth A. Hopkins
Transparent watercolor
11¹/₂" × 8¹/₂"
(29cm × 22cm)

Creating Convincing Form and Space

WHETHER THE ARTIST IS CREATING A realistic, abstract or nonobjective composition, understanding the process of creating the illusion of three dimensions on a two-dimensional surface is vital to the success of the painting. This chapter explores the elements of creating form as well as two systems of representing space—which, if used together, will result in paintings with very convincing three-dimensional qualities.

HAIKU #9
Linda Stevens Moyer
Transparent watercolor
29$\frac{1}{2}$" × 42" (75cm × 107cm)
Collection of Caroline S. Lenert, Los Angeles, California
Photograph by Gene Ogami

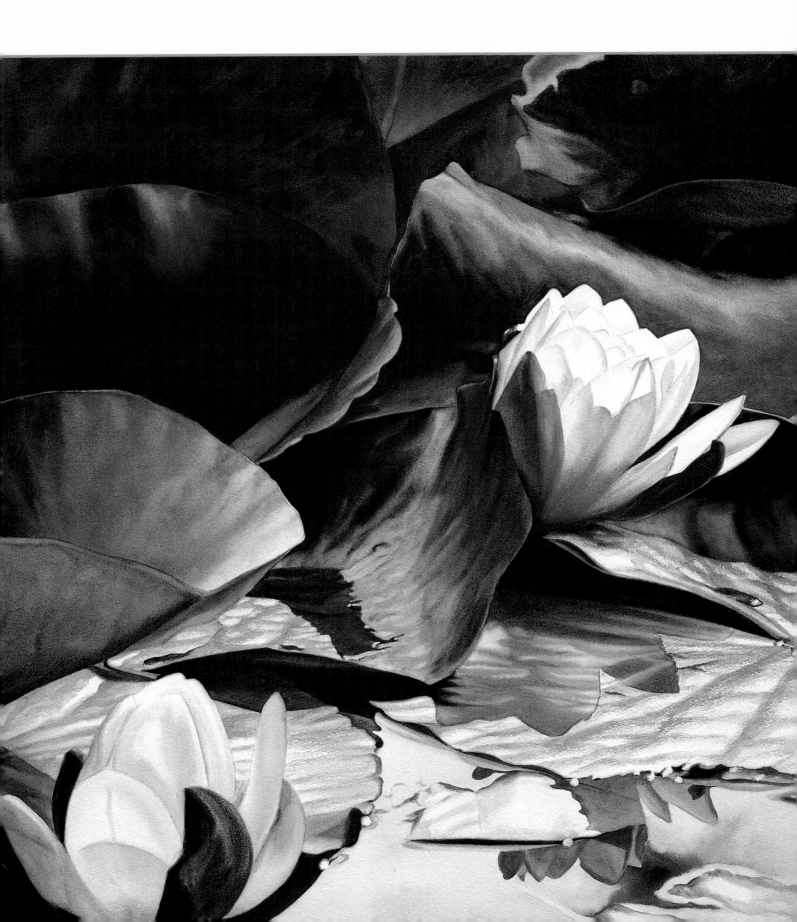

Light and Shadow Reveal Form

We perceive our world, in part, as a result of the various amounts of light that enter our eyes from reflecting surfaces around us. Some surfaces are highly reflective; others return very little light to us.

As artists it is important to train our eyes to be highly discriminating in a number of ways. Changes of value (dark and light) across the surface of an object reveal the form of that object to us. To represent light accurately, we must first accurately observe the lights and darks that describe form.

Many of the objects that you paint will be a combination of curved and flat surfaces. Understanding how light interacts with each of these surfaces will help you to see the value changes and record them in your paintings. The result is a convincing illusion of three-dimensional form.

The Curved Surface

An object having a curved surface will have a system of darks and lights that changes constantly and smoothly. Whenever a curved object is to be depicted, the artist should look for a core shadow, reflected light on the dark side and a slight shadow on the light side, as well as the gradual change from light to dark values across the surface of the object. Where these different shadows and lights occur will depend on the direction from which the light encounters the object. Noticing these subtle changes of light and dark will help you paint a convincing curved form.

The Flat Surface

We are able to perceive an object with flat surfaces, such as a cube, because of the contrast of value between each of the surfaces. No lines are needed to establish form. Each side of a cube is perpendicular to the others and receives a different proportion of light. The value does not stay constant across each surface; it changes slightly as each side recedes into space.

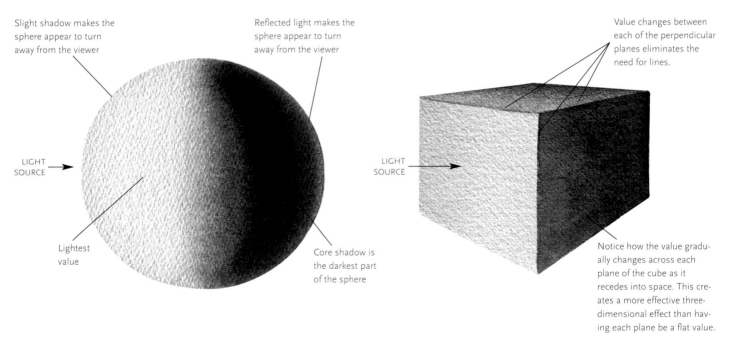

Slight shadow makes the sphere appear to turn away from the viewer

Reflected light makes the sphere appear to turn away from the viewer

LIGHT SOURCE

Lightest value

Core shadow is the darkest part of the sphere

Value changes between each of the perpendicular planes eliminates the need for lines.

LIGHT SOURCE

Notice how the value gradually changes across each plane of the cube as it recedes into space. This creates a more effective three-dimensional effect than having each plane be a flat value.

Curved Surface: A Sphere
This sphere is illuminated with a strong directional light coming from the left. Notice how the light gradually changes across its surface.

Flat Surface: A Cube
One of the first steps toward abstraction or flattening an object is to draw lines around it or within the boundaries of the object. If our objective is to make an object look very three-dimensional, we must eliminate those lines by using contrasting values within the object to make those lines unnecessary.

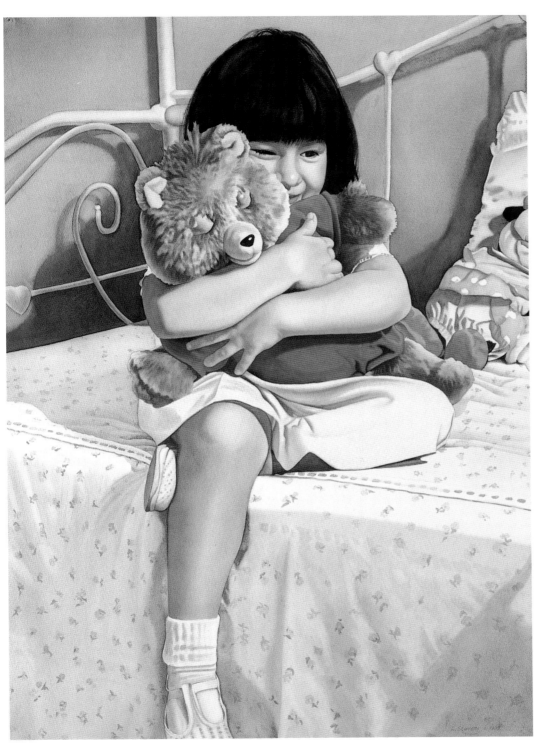

Seeing Light and Shadow

Notice the play of light across the various objects in this painting. Can you see core shadows? Reflected light on the shadowed side of forms? Shadows on the edges of the light sides of the forms?

YADIRA
Linda Stevens Moyer
Transparent watercolor
42" × 29¹/₂" (107cm × 75cm)
Collection of Mr. and Mrs. Jose Damian, Mission Viejo, California
Photograph by Gene Ogami

■ *assignment #13*

On watercolor paper, paint a sphere and a cube using the watercolor techniques that you have learned. Use your largest round brush. Portray each object only with varying values—no drawn lines!

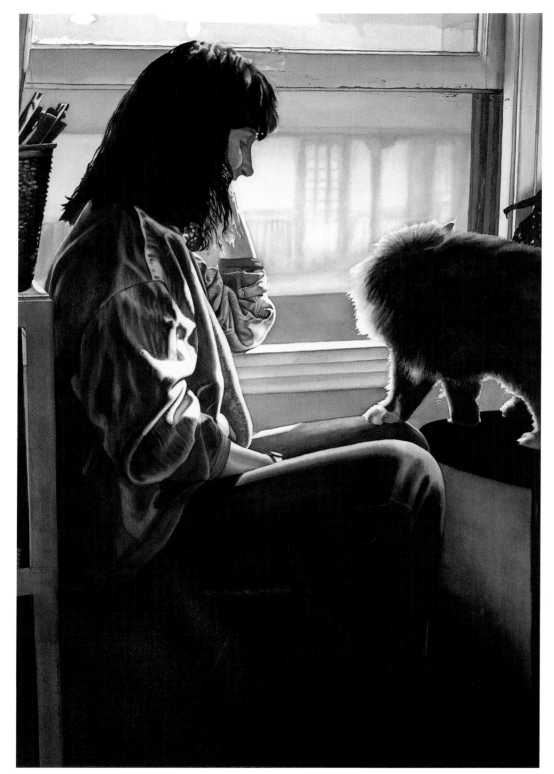

■ *assignment #14*

Light a very simple object (perhaps an egg or a smooth ball) in several different ways: from the top, back, front, bottom or a side. Observe how the values on the object change as the direction of the light changes. Are there core shadows in each of these situations? Where is the reflected light? What about cast shadows? Paint the object in several different lighting situations.

Variations of Light

The light varies across each flat surface in this painting. This is caused by nearby objects either blocking light or providing reflected light to different parts of the composition.

JAYE AND ABERNATHY
Linda Stevens Moyer
Transparent watercolor
49" × 33" (124cm × 84cm)
Collection of the artist
Photograph by Gene Ogami

Value Opposition

In order to see changes of plane or one object against another there must be a value change. We are able to see the world around us not because there are lines around each object but because of constant value changes between the surfaces of overlapping objects and between positve and negative space.

Creating opposing values between positive space (the objects you're painting) and negative space (the space around them, or background) not only defines the boundaries of the objects, but also begins to create a feeling of atmosphere around the objects.

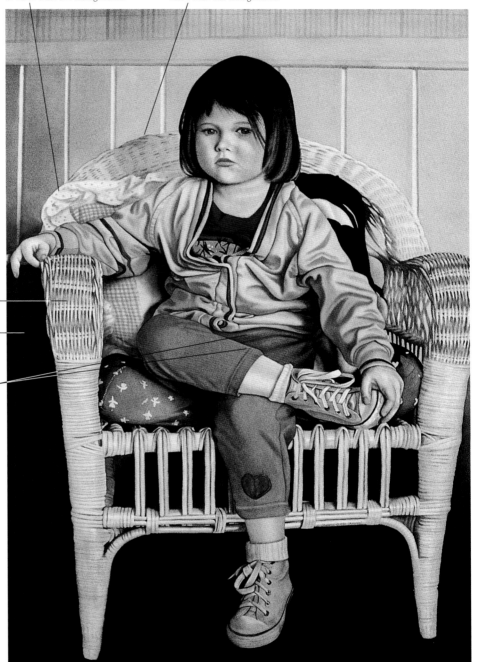

The edge of the chair is lighter in value than the background.

Here, the edge of the chair is darker in value than the background.

Positive space

Negative space

Notice the difference in value between these two overlapping forms.

■ *assignment #15*

Practice using opposing values in a painting. Use a simple, well-lit still life as your subject. Eliminate the need for any lines between forms and between the forms and the background by painting opposing values. Use a pair of complementary colors only. See how many variations of color and value you can create by mixing those two colors.

Establish Form and Space With Opposing Values

Notice how the values oppose each other in this painting. This value opposition makes it possible for us to perceive the various forms within the painting as well as the space between and around them.

AMANDA
Linda Stevens Moyer
Transparent watercolor
42" × 29¹/₂" (107cm × 75cm)
Collection of the artist
Photograph by Gene Ogami

Space: Setting the Stage

An understanding of both linear and atmospheric perspective is vital to you as an artist so that you can create believable form and space in compositions. As a juror I have encountered many paintings that would have been award winners if only the artists had understood the fundamentals of perspective.

Linear Perspective

Linear perspective is a system based on the following premise: Lines that are parallel to each other converge as they recede into the distance. They meet at a place (sometimes on the horizon line) called a *vanishing point*.

As an artist, you need to have a good understanding of one-, two- and three-point perspective. To summarize this topic briefly:

- In one-point perspective, only one vanishing point is used. This type of perspective is limited to forms that present one side that is parallel to the horizon line.
- Two-point perspective uses two vanishing points. It is the most-used means for representing space in an artist's work.
- Three-point perspective is used when looking down or up at an object and when two sides of that object can be seen.

You should study this subject independently to learn more about the topic. There are many books that will give you a good understanding of linear perspective.

Some of the effects of linear perspective are:

- Larger objects will appear to be closer than smaller objects.
- Objects that overlap other objects look closer.

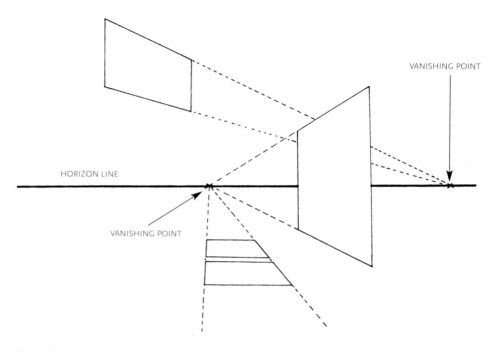

One-Point Perspective
These planes have been drawn in one-point perspective. There are two vanishing points on the horizon line in this drawing, but notice that the receding parallel lines of each plane converge at a *single* vanishing point. In other words, only one vanishing point was used to draw each shape.

- Objects below the horizon line will look closer if they are represented lower on the paper.

Atmospheric Perspective

Atmospheric (or aerial) perspective concerns the ways in which the thickness of the atmosphere or air around us changes the way we see nearby objects versus distant objects.

Closer objects are perceived as having:

- More surface detail and texture.
- More value contrast. The lightest lights and darkest darks should be reserved for the foreground. White and black will pop forward in a painting and should be used only as an aid in representing near space.

- More defined (or harder) edges. As forms recede into the distance, edges become less defined (or softer).
- More volume. Giving closer forms more modeling in light and dark—and therefore more three-dimensional qualities—will emphasize their closeness to the viewer.
- Brighter color. More intense colors come forward visually.
- Warmer colors. Warm colors come forward; cool colors recede.

Creation of deep space will be enhanced if you paint a succession of planes receding in space. The viewer's eye will be led methodically from the foreground through successive planes of middle ground to the background.

In this case, the two vanishing points are located off
the paper, where each set of lines is heading.

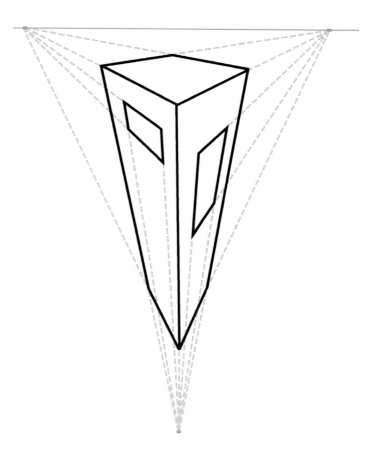

Two-Point Perspective

This Victorian house in Spearfish, South Dakota, was drawn in two-point
perspective. There are two vanishing points, both located off the page. To
obtain less distortion in the objects depicted, it is important to place the
vanishing points at a distance from the subject. This often necessitates
placing the vanishing points off the paper.

VICTORIAN HOUSE
Linda Stevens Moyer
Pen and ink with watercolor
23¹/₂" × 18" (60cm × 46cm)

Three-Point Perspective

A third vanishing point may be used if a structure is placed above or below
the horizon line. In this example, we are looking down at the object and the
third vanishing point is located below both the horizon line *and* the object.

Less Contrast, Less Intensity in the Distance
In this painting, the nearer rocks have a stronger value contrast than the more distant ones, emphasizing their proximity to the viewer.

WATER LIGHT #32
Linda Stevens Moyer
Transparent watercolor
29¹/₂" × 42" (75cm × 107cm)
Collection of Ron and Janice Carl, West Linn, Oregon

■ *assignment #16*

Select a location outside that has a foreground, middle ground and background. Use the watercolor techniques that you have learned and as many of the ways of representing space as you can to create a landscape that shows deep space. You may even wish to exaggerate the deepness of the space. You are not limited in color on this assignment.

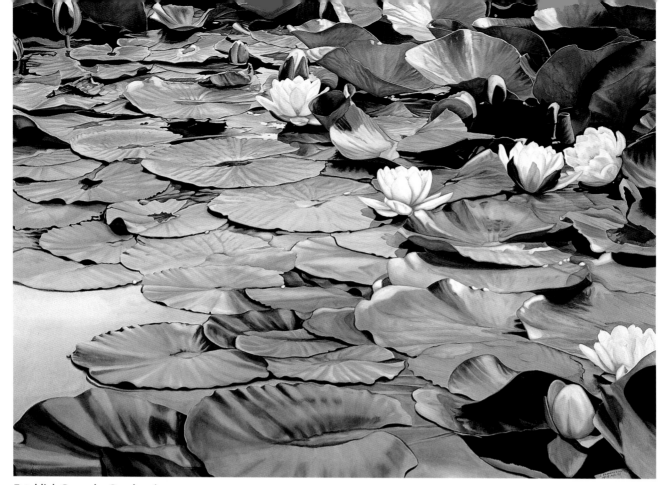

Establish Space by Overlapping

The system of overlapping leaves and flowers in this painting establishes a spatial order which helps the viewer to read the painting dimensionally. The lily pads at the bottom of the painting appear closer because they overlap and are bigger than the others.

HAIKU #5
Linda Stevens Moyer
Transparent watercolor
53¹/₂" × 68" (136cm × 173cm)
Collection of Mr. and Mrs. Robert Magdane
Photograph by Gene Ogami

Linear and Atmospheric Perspective

This painting is an excellent example of both linear and atmospheric perspective. Can you pick out the various tools that the artist has used to create a feeling of deep space?

FROM MY WINDOW
Martha L. Bunch
Transparent watercolor
22" × 15" (56cm × 38cm)

Building Texture in Your Paintings

THERE ARE A NUMBER OF WAYS TO enhance the three major painting techniques that you have learned. In this chapter, you will discover additional ways of saving or regaining the white of your paper as well as creating textures that will heighten the realistic quality of your paintings.

FEATHER LIGHT #7
Linda Stevens Moyer
Transparent watercolor
29¹/₂" × 42" (75cm × 107cm)
Collection of Brian George,
Simi Valley, California
Photograph by Gene Ogami

Using Masking in Many Ways

We covered the use of masking fluid in chapter two. The following examples will show additional ways of using it not only to save the white surface of the paper but also to create texture. I remove masking fluid with a rubber cement pickup when the painting is completed.

Drafting tape and similar materials may also be used to save the white of the paper.

Working Wet-Into-Wet

The traditional way of using masking fluid is to apply it to dry paper. Hard-edged shapes result. Masking fluid can also be applied to moist paper. Soft-edged shapes can be formed and saved by applying the masking fluid in this way. Note that shapes formed with masking fluid on damp paper will be more difficult to control as they tend to bleed over the wet surface.

■ **TRY THIS FOR:** *cloud shapes in the sky and moss on rocks.*

Spattering

A texture may be made by dipping a toothbrush into masking fluid, tapping the brush on a hard surface to remove the excess and then dragging a piece of cardboard or your finger along the bristles to spatter the fluid on the paper. After the spatters are dry, the surface can be painted and the masking fluid removed once the paint is dry. This process can be repeated in layers (working light to dark) to build a complex area of color and texture. Remember to remove all of the masking fluid when the painting is complete.

■ **TRY THIS FOR:** *sand on a beach, texture on rocks or sea spray.*

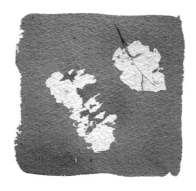

Printing

Masking fluid can also be applied to various objects. They are then pressed on the paper, leaving an imprint of the shape.

■ **TRY THIS FOR:** *incorporating the prints of real objects (i.e. leaves, bark) into your paintings when working on location.*

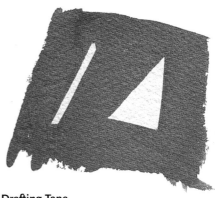

Drafting Tape

Shapes may be cut from drafting tape or a similar product and applied to the watercolor paper. These shapes should be burnished with your thumbnail so that they are firmly attached to the paper around all of the edges. Then you can apply watercolor without losing the areas covered by the tape. After the paint has dried, the tape is removed, leaving a pristine white surface.

■ **TRY THIS FOR:** *fence posts and sails on sailboats.*

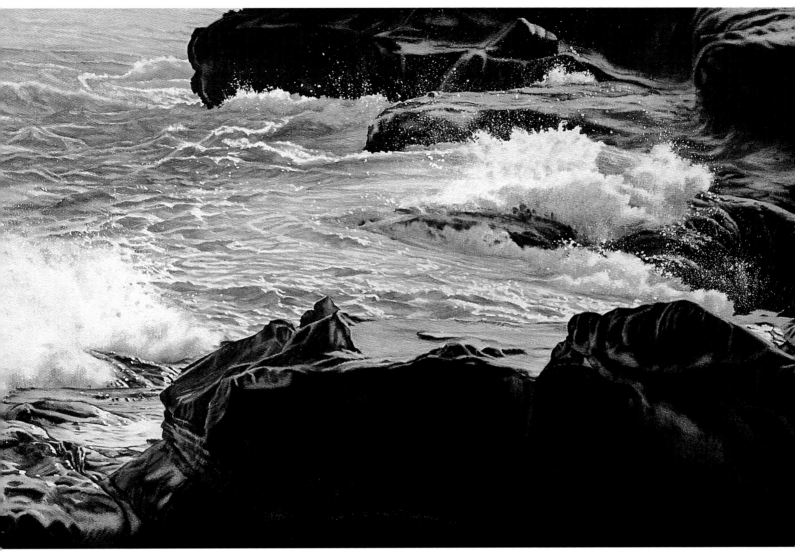

Spattering for Spray

Masking fluid was spattered to create the appearance of spray from the crashing waves on the rocks at upper center. I held the toothbrush to the lower left of the rocks and aimed the spatter so that it would be cast up toward the right onto the rocks. When the painting was completed and dry, I used a rubber cement pickup to remove the tiny spots of masking fluid.

LA JOLLA #5
Linda Stevens Moyer
Transparent watercolor
29¹/₂" × 42" (75cm × 107cm)
Collection of La Jolla National Bank,
La Jolla, California

Lifting Paint

There are times when an area of a painting needs to be lightened after the paint has already been applied. A number of methods to lift paint can be used with varying effectiveness.

Scratching

In this technique, use the point of a sharp utility knife to scratch the surface of dried paint to draw white lines across the surface. The kind of white line created will depend on the surface qualities of the paper. This example was done on rough watercolor paper.

The scratching will raise tiny portions of the paper. Usually you will want to use your thumbnail to flatten these so that they will not cast shadows in the finished work.

■ *TRY THIS FOR: weathered wood, telephone lines, fishing lines or tiny highlights that you discover are needed after a painting has been completed.*

Scraping

The blade of a nonserated knife created the lighter shapes in this example. I held a knife at an angle to the surface of the paper. I then drew the blade toward me, pressing out some of the wet paint and allowing the white of the paper to come through the wet paint. (The handles of some watercolor brushes are cut off at a slant providing a tool to create this effect.) This technique is best used when the paint begins to lose its gloss, because if the paint is too wet, the color will flood back into the scraped area.

The darker lines were created by using the point of the knife. When the point is used to scratch into the wet paint, it roughens the surface of the paper and allows more paint to flow into this area, leaving a darker value. Try using various tools to get a variety of effects.

■ *TRY THIS FOR: grass, feathers, fur or regaining a lighter area in your painting after a wash has been applied.*

Cutting Out Shapes

Sometimes as you work on a painting, you will find that you need a completely white shape in your composition (one that you had not previously planned). In this example, a utility knife was used to cut a shape through the top ply of the paper. The cut shape was then peeled off, exposing the white paper underneath. This technique works best on heavier paper such as 300-lb. (640gsm).

■ *TRY THIS FOR: working back into heavily stained areas to regain the white of the paper.*

Wet Lifting

Wet lifting is done while the paint is still moist. It is most effective if done while the painted surface has only a slight sheen. Use a clean wet brush that has had most of the moisture squeezed out of it. Make a stroke of the desired shape on the surface of the previously applied wash. The brush will act as a sponge, removing the paint.

The amount of paint removed (or lifted) will depend on the characteristics of the paint used (e.g. staining or nonstaining, dye or sedimentary). If the paint is too wet, it will flow back into the area that has been removed. Soft-edged shapes result from this technique.

■ *TRY THIS FOR: soft edges of water ripples.*

Dry Lifting

Dry lifting is done on a dry painted surface. Use a wet brush to apply clean water in the desired shape to be lifted. Then use a paper towel to mop up the water. Usually this is done by briskly drawing the towel toward you with a firm pressure. Once or twice should be enough. Do *not* scrub as this may remove some of the paper surface. It is also important to use this only on a paper that has a durable surface. The effectiveness will depend on the characteristics of the paint to be removed. If the paint is a staining color, very little change may occur.

■ *TRY THIS FOR: putting highlights or reflected light back into objects in your paintings.*

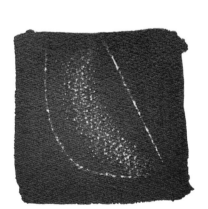

Sandpaper

Sandpaper may be used on a dry painted surface to expose a lighter value. This example was done on rough watercolor paper. The lines were created by folding the sandpaper and then using the folded sandpaper to reveal the white of the paper. The technique can also be used to create texture.

■ *TRY THIS FOR: rocks, sand or the light side of an orange.*

Salt on a Wet Surface

When table salt is sprinkled on a wet painted surface, the salt is dissolved by the water in the paint mixture. It pushes the paint particles away, creating lighter spots where the salt crystals have been. If the salt is applied too densely, it will interfere with the shapes that are created by this process. The salt should be removed after the paint has thoroughly dried.

■ *TRY THIS FOR: dappled sunlight on water or a forest floor.*

Salt on an Almost Dry Surface

If the surface dries to the point that it has almost lost its sheen, small star-like shapes will result. Remember to remove the salt only after the paint has thoroughly dried.

■ *TRY THIS FOR: sparkles in snow.*

Other Texture Effects

Texture can play an important role in your paintings by creating surface interest as well as developing a more convincing realism in the objects you depict. Techniques can be mixed and matched and combined to make your own unique textures. Remember that you are working with a transparent medium; textures can be layered as well as colors and values!

There are many different materials such as ink, wax and gels that can be combined with transparent watercolor to create texture. I have limited the following texture examples to those substances that would be acceptable in a purely transparent watercolor.

Sand or Gravel
Bird gravel was applied to wet paint to create this texture. As the paint dried, particles of pigment were pulled toward the small pieces of gravel. They collected around the shape of the gravel and left an impression of the gravel itself.

■ *TRY THIS FOR: sand on a beach and rocks.*

Backruns
Backruns or backwashes can be fun to play with. They are created by running a very wet brush down the side of a wash when it has almost lost its gloss. The water bleeds back into the color and creates a distinctive texture.

■ *TRY THIS FOR: the variegated colors of a tulip or the negative space in a painting.*

Drybrush
In this technique, a brush is dipped into paint and then wiped almost clean. While holding the brush almost horizontally—so that the full length of the bristles contact the surface of the paper—move it across the surface of the watercolor paper. An old brush that has lost its point works best for this. The technique can be layered (light to dark) if each layer is allowed to dry before the next is applied. This example has been painted on rough watercolor paper.

■ *TRY THIS FOR: denim, rocks, sand, foliage, stucco, brick, weathered wood, feathers and fur.*

Rubbing Alcohol
Rubbing alcohol applied to wet paint leaves a distinctive light shape with a darker center. As with many of the techniques, this works best if the paint is not too wet. I use a syringe-type instrument to control the flow of the alcohol. You can find this tool in a number of art supply catalogs. Alcohol also can be sprayed onto a moist surface from a spray bottle. This leaves very tiny shapes.

■ *TRY THIS FOR: bubbles and flower shapes.*

Waterspots
Dropping clean water on a painted surface that is almost dry makes waterspots, also called *blooms* or *oozles*. Instead of clear water, different colors of paint can be dropped from your brush on the surface to create a different effect. Fine mist from a spray bottle will create tiny waterspots that make the surface of the paint look pitted.

■ *TRY THIS FOR: lichen and rocks.*

Toothbrush Spattering

Toothbrush spattering on wet or dry paper can be used in a number of different ways to create texture, soft-edged shapes or a transition of value and color across a shape. Practice layering toothbrush spatters in different colors, working from light to dark. Allow each layer to dry before applying the next.

■ *TRY THIS FOR:* *sand, rocks and sea foam.*

Sanding or Scraping the Paper Before Painting

In this example, the surface of the dry watercolor paper was scraped before the paint was applied. The surface accepted more paint where it had been roughened. A darker texture was the result.

■ *TRY THIS FOR:* *the texture of velvet clothing or the softness of grass in a meadow.*

Stamping With Other Objects

Other objects can be used to stamp textures on your paper. Apply the paint to the object, then press the object on your watercolor paper. Using a little liquid soap with your paint will help the paint adhere better to plant forms or other objects that have a waxy surface.

■ *TRY THIS FOR:* *recording various objects in your painting environment that will enhance your composition (leaves and twigs, for example).*

Stamping With a Sponge

Different kinds of sponges will leave different marks on the paper. This technique may be layered to create complex textures and color effects. (Remember to allow the paint to dry between each layer!)

Be careful with texture created in this way. You don't want the viewer to look at your painting and say, "Hey, look at the sponge prints." The texture should merge with and enhance your composition.

■ *TRY THIS FOR:* *foliage, tree bark and underwater shapes.*

Stencils

A toothbrush and wire screen were used to create this texture. It was necessary to wipe most of the paint from the toothbrush before rubbing it vigorously over the firmly held wire screen. An impression of the holes in the screen were left. Other stencil forms can be used such as lettering stencils or shapes that you cut from cardboard or four-ply bristol board.

■ *TRY THIS FOR:* *texture in cloth, a wire screen on a building, the lettering on an old barn or repetitive shapes in your composition.*

Plastic Wrap

When plastic wrap is applied to the wet surface of a painting, it creates a very distinctive texture. The wrap may be maneuvered to create various shapes or directional lines in the composition. Once in position, the plastic wrap should not be removed until the paint underneath is completely dry.

■ *TRY THIS FOR:* *waves and clouds.*

Putting Texture Techniques Into Practice

You will discover your own ways of using these techniques as you respond to subject matter in your paintings. You are limited only by your own vision and inventiveness.

A light Yellow Ochre wash was brushed over this area first and allowed to dry. Then, progressively darker layers were drybrushed on to build up texture and shadow over the rock's surface (Cadmium Yellow Pale and Burnt Sienna dulled with Ultramarine Blue; Burnt Umber dulled with Ultramarine Blue).

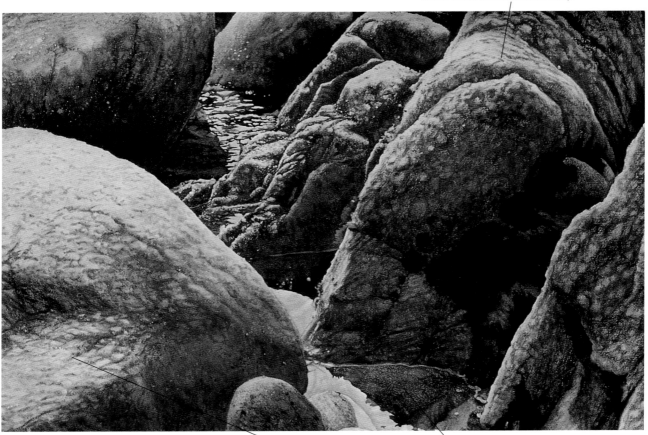

Drybrushing for Rocks

The drybrush technique has been used extensively in this painting. The drybrushed layers varied from one layer on top of a wash to five or six layers in some places. The painting was done on 300-lb. (640gsm) rough watercolor paper, and my palette consisted of Cadmium Yellow Pale, Cadmium Orange, Ultramarine Blue, Alizarin Crimson, Yellow Ochre, Burnt Sienna and Burnt Umber.

WATER LIGHT #36
Linda Stevens Moyer
Transparent watercolor
40" × 60" (102cm × 152cm)
Collection of the artist

Masking was spattered over this area and allowed to dry before a light Yellow Ochre wash was applied. Lighter drybrushed layers of cool browns were overlaid with dark, cool drybrushed shapes to give the effect of weathered rock. Various tints of Cadmium Yellow Pale were applied over areas where masking was removed to make these spots blend more with the rest of the painting.

Medium values of Yellow Ochre and Burnt Sienna were overlaid with a dark, dull wash of Burnt Umber and Ultramarine Blue. Salt was sprinkled on the surface while the dark wash was still wet. The resulting texture allows us to see the light warm colors that were applied first.

■ *assignment #17*

Select still-life objects or a landscape that contains a lot of texture. Try to duplicate the textured surfaces that you see using the techniques in this chapter.

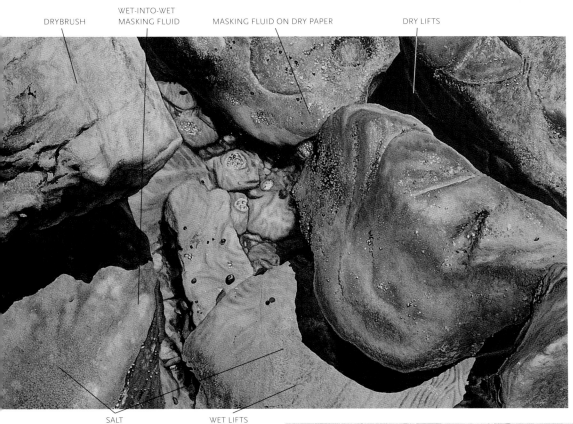

DRYBRUSH · WET-INTO-WET MASKING FLUID · MASKING FLUID ON DRY PAPER · DRY LIFTS

SALT · WET LIFTS

Putting It All Together

This painting incorporates many of the techniques mentioned in this chapter. Extensive drybrush was used in multiple layers of color and value. Spattered masking fluid and paint were also used to enhance the texture of the rocks. Wet lifting and dry lifting were invaluable tools in the painting process. Notice that masking was also applied in the traditional way to save the white of the paper.

WATER LIGHT #27
Linda Stevens Moyer
Transparent watercolor
29¹/₂" × 42" (75cm × 107cm)
Collection of Don and Herta Anderson,
Laguna Beach, California

■ *assignment #18*

A nonobjective painting is one in which no recognizable objects exist. Line, value, shape, color and texture are used without reference to subject matter.

Paint a nonobjective textural composition. Divide your paper into interesting shapes of different sizes. In each shape, experiment with paint-lifting and texture-making techniques. Try to develop a center of interest. If you create a transition—a change of color, value or texture—across each shape, this will lead the viewer's eye smoothly from shape to shape and your composition will be more effective.

One artist's completion of assignment 18.

TEXTURE STUDY
Ron Tate
Transparent watercolor and ink
22" × 30" (56cm × 76cm)
Collection of the artist

Color and Value Variation Create Texture

Many textures are the result of the artist's close observation of small shapes of value and color as they play across the surface of an object. The parrot's feathers in this painting are a good example.

FEATHER LIGHT #3
Linda Stevens Moyer
Transparent watercolor
42" × 29¹/₂"
(107cm × 75cm)
Collection of Scott and
Christa Roland,
Granada Hills,
California

MAKE A PAINTING WITH PLASTIC WRAP

Artist John R. Koser has used this technique extensively in his work. The following demonstration shows how he has used plastic wrap to develop several areas of the same painting.

MATERIALS

240-lb. (510gsm) rough watercolor paper

3B graphite pencil

Masking fluid

Lightweight plastic wrap

Brushes
- 2-inch (51mm) Skyflow
- 1-inch (25mm) Grumbacher Aquarelle
- nos. 3 and 8 Winsor & Newton Series 7 rounds
- no. 2 round (for applying masking fluid)

Watercolors
- Alizarin Crimson
- Cadmium Yellow
- Winsor Blue
- Winsor Green

step 1 completed

step 1 | MAKE A DRAWING AND BEGIN PAINTING THE SKY AND WATER

Make a light drawing. Protect the sea gull shapes with masking fluid and a no. 2 round brush. Mix trial patches to create the warm purple-gray value of the sky. Wet the sky area, then charge it with yellow, red and blue in small amounts. When the area has lost some of its glistening wetness, add more blue to enhance the color of the sky. While the paint is still wet, apply plastic wrap. Stretch it, press it and make adjustments as needed to create interesting shapes. When the sky has dried, remove the plastic wrap.

Next, wet the distant band of surf (except for the white breaker) and charge it with yellow, red, blue and green. As the paper begins to lose some wetness, wet the white surf area and soften the edges that meet the pigmented areas. Then stretch plastic wrap over the damp area, adjusting it to create interesting shapes and the illusion of motion. If the textural lines that occur when the plastic wrap is laid down appear OK, you may not need to adjust the wrap at all. Allow the paint to dry. Complete the next band of surf in the same way.

Start working on the large wave shape in the middle ground by wetting this large area with a 2-inch (51mm) Skyflow brush, keeping the surf and white breaker areas separate with a dry paper space ¼" (60mm) wide between them. Into the cresting wave, charge yellow, red, blue and green, allowing the colors to mix on your wet paper. Tint the white foam of the crashing wave with diluted amounts of the primary colors so it doesn't appear as a flat, lifeless paper cutout. As the paper dries to a satin finish, use a damp brush to join the dark edge and the white edge in a random fashion. Stretch plastic wrap over the entire wet area and allow the surface to dry completely.

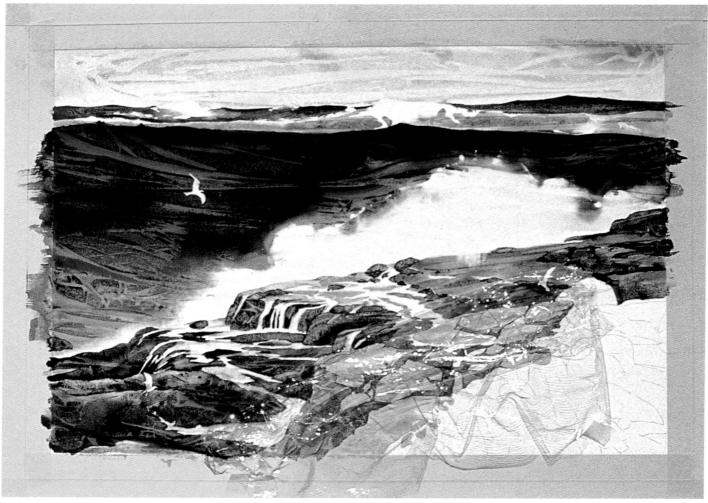

step 2 | **BEGIN THE FOREGROUND ROCKS**

Divide the foreground rocks into workable areas, and use all the colors to paint them. For the rocks in the immediate foreground, use plenty of yellow and red over the blue and green. This will make the rock shape visually move forward and push the cooler parts of the painting back. The warm hues in the foreground support the perspective of the painting. Save the white areas by painting around them. As each area is completed, lay plastic wrap over the fresh paint and allow it to dry completely.

Plastic Wrap | TIPS

- Use the lightest-weight plastic wrap you can find. It is manageable and produces a greater number of textural shapes or lines. The painted paper will also dry faster under its cover.
- The wet painted areas should have a satiny wet look when covering with plastic wrap.
- The paint must be entirely dry before the wrap can be removed. Some paint will peel away with the wrap, leaving large and small textured areas.
- If a particular textural motion or direction is desired, do a trial patch on the same kind of surface and with the same pigments intended for painting.
- Plastic wrap must be incorporated throughout a painting for continuity. This is the key to success.

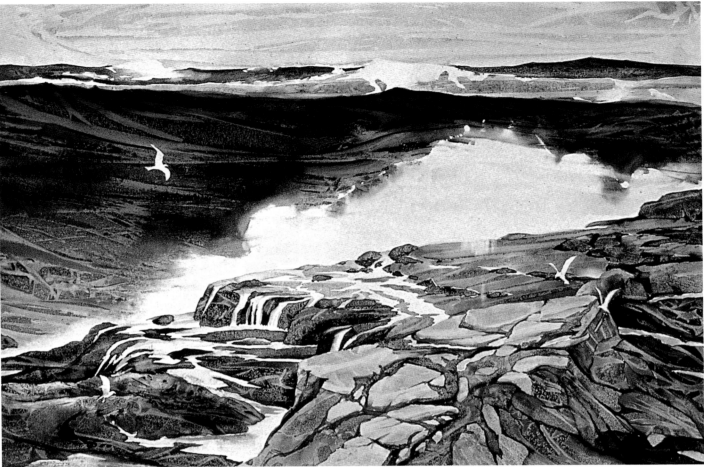

step 3 | **FINISH THE ROCKS AND DETAILS**

Finish the rocks using the same plastic wrap technique. Remove the masking from the sea gull shapes and carefully soften some selected edge areas with a wet no. 8 round brush. This blending of edges pulls the hard-edged shape into the style of the rest of the painting.

Often, the actual area treated with plastic wrap needs no changes. However, minor adjustments can be made with a wet brush or by dabbing at the wet surface with a paper towel. Adding fresh paint to these areas should be done only when absolutely necessary.

The finished painting has been enhanced by the use of plastic wrap to create texture in each of the subject areas. The drafting tape that was used to attach the paper to the board will give you a nice, clean edge around the painting.

PACIFIC SERIES VII
John R. Koser
Transparent watercolor
23" × 33" (58cm × 84cm)
Collection of Dr. and Mrs. David P. Tonnemacher,
California

About the Artist

John Richard Koser, a past president of Watercolor West, studied art at the Art Center of Colorado Springs. He has participated in numerous solo and group exhibitions, and he teaches workshops in southern California, his home state. His paintings appear in many private and corporate collections throughout the United States.

How We Perceive Color and Light

THIS CHAPTER PRESENTS A FORMULA for creating luminosity, as well as additional color theories that will enhance the viewer's perception of light.

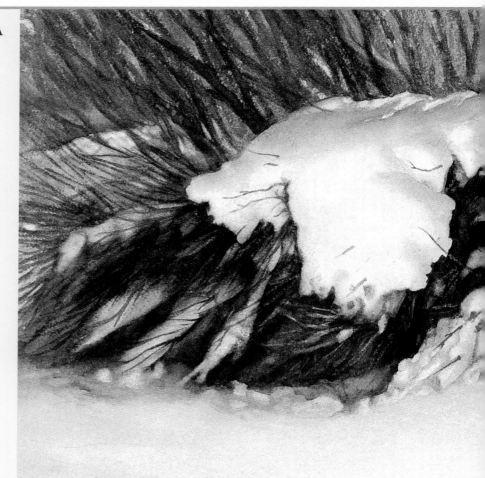

WASATCH WINTER #2
Linda Stevens Moyer
Transparent watercolor
22" × 30" (56cm × 76cm)
Collection of the artist
Photograph by Borge B. Andersen & Associates

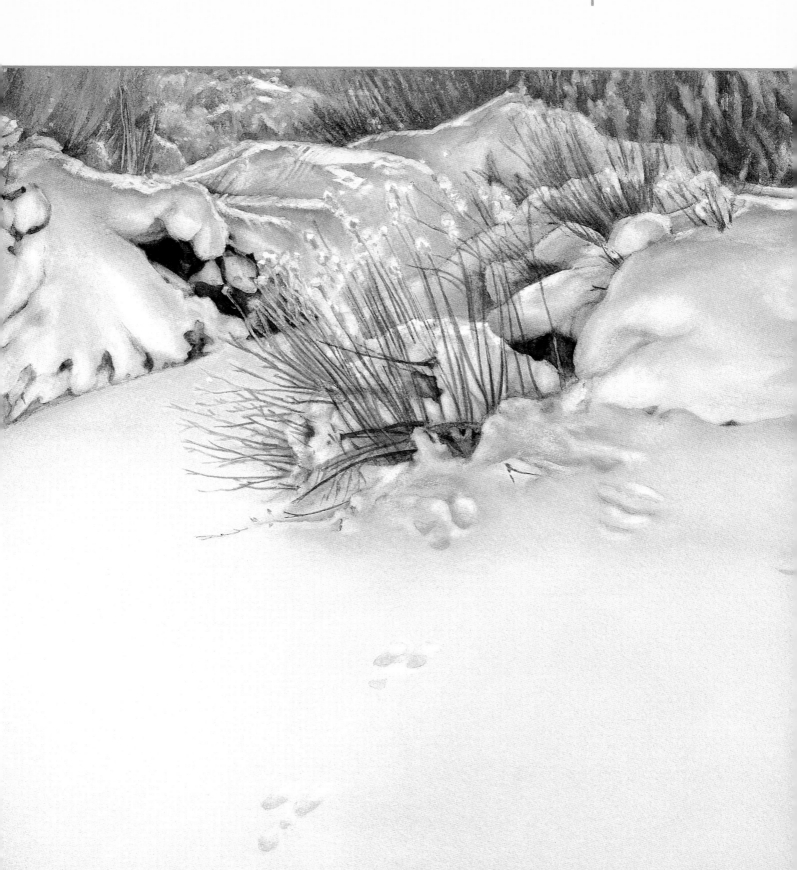

The More You Look, the More You Will See

Sight is the most important possession that an artist has. As we use the gift of sight, our perceptual abilities increase. My vision has changed and become more acute over the years: I now notice light phenomena that I was unaware of even ten years ago.

As a young artist, I listened to other artists discuss the quality of light and how it differed between various locations. It disturbed me that I wasn't able to visually distinguish what others seemed to take for granted. One morning, I awoke and looked through the bedroom into the bathroom where my husband had left the light on. It was an epiphany for me to recognize that the color of the natural light coming in through the window in the bedroom was a very different color from the incandescent light in the bathroom. From that moment on, I was much more aware of the different colors and qualities of light in various situations.

Artist Wayne Thiebaud has always

been a hero of mine. I love the way he uses color in his painting. For many years, I thought that he was just being marvelously inventive with color. In a number of his works you will see a thin red-orange line on one side of the painted objects and possibly a blue-green line on the opposite side. The color vibrations that result when these colors interact with the colors of the objects are wonderful.

Eventually, I began to see these colors on the edges of real objects in strong sunlight. With a little research, I discovered that this phenomenon is called *halation*. When an object is placed in a strong, direct light you may see a thin red-orange line on the side nearest the light source. There may be a line of the opposing color (blue-green) on the opposite side. This has been explained in various books as a manifestation of how our eyes work. Because our eyes are binocular and because it is impossible to hold our eyes completely still when we are looking at an

object, the edges are fuzzy. This is true, but I also believe that it is due to the refraction of light as it encounters the edges of the object. The light is separated into different wavelengths, much like when we see light enter a prism and become fragmented as it leaves the opposite side. The phenomenon of halation may be seen in photos as well as with the naked eye.

Because halation occurs naturally in light and because representing light is one of my obsessions, I put it into my work whenever I see it. Seeing color works in the same way. The more you use your eyes and the more you look for a particular color in your still life, landscape or any subject, the more of that color you will see. The more you exercise your sense of sight, the more color will become apparent to you. And you will find that as you see more color, you will put more color into your work.

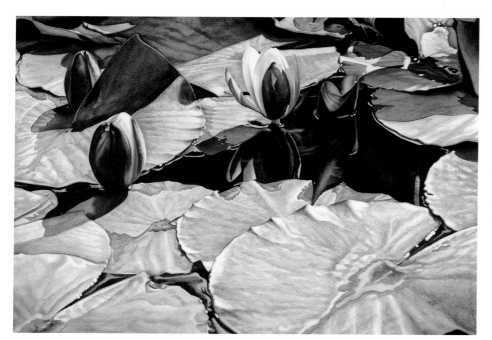

Halation
If you look closely you can see a thin red-orange line on the edges of some of the forms. This halation is one of the phenomena that occurs when an object is in strong light.

HAIKU #3
Linda Stevens Moyer
Transparent watercolor
29¹⁄₂" × 42" (75cm × 107cm)
Collection of Martha Bonzi,
Boulder, Colorado
Photograph by Gene Ogami

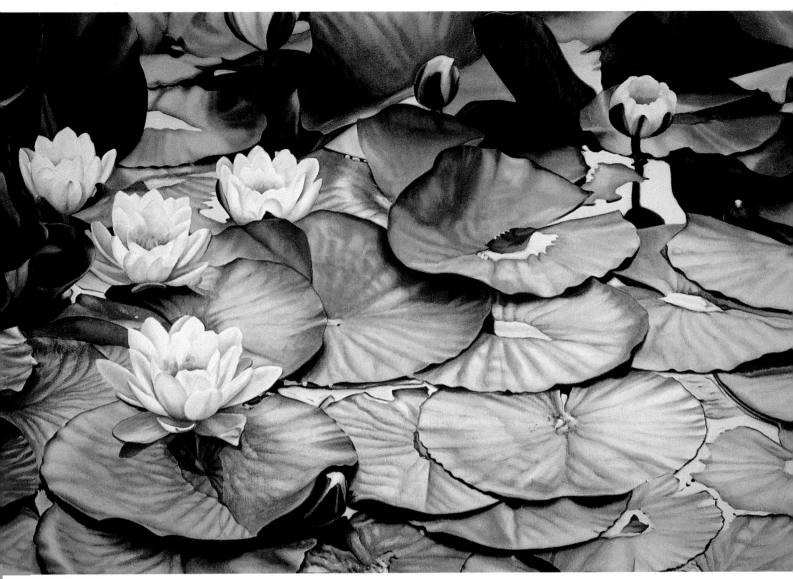

HAIKU #16
Linda Stevens Moyer
Transparent watercolor
29¹/₂" × 42" (75cm × 107cm)
Collection of Mrs. Beverly Leggett,
Beverly Hills, California

Notice the halation, the thin red-orange line on the right side of some of the forms. The light is coming from the right in this painting.

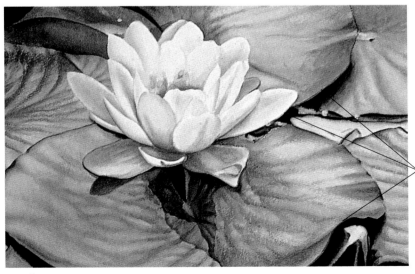

Detail

assignment #19

This is one of my favorite assignments to help students become more aware of color. Work from real objects, not from a photo. The format for your composition will be a long, thin rectangle, about 8" x 16" (20cm x 41cm), that you may use either horizontally or vertically. After trying a few thumbnail sketches first, draw your composition on your paper, and follow these steps:

1. Divide the rectangle into five different sections, either arbitrarily or in a planned way.
2. Paint each section in full color, *just as you see it*. Work in each section independently, completing each one before going on to the next. Cover the sections that you are not working on with a piece of paper while you are painting.

As you develop each section, concentrate on seeing a different specific color. It will help to label each section before you start in terms of the color you will look for in that section. As you paint the section that is designated as red, ask, "Where do I see red in the subject?" Then paint red wherever you see it.

Also notice where red is influencing another color and mix that particular color. For example, if you have a dull green in your composition, you know that this green has been influenced by red; therefore, you will mix red with your green in order to duplicate that color when painting it. You will paint all of the other colors you see as well, but concentrate on seeing where red influences the colors in this section of the composition. If you don't see red, or if you don't see red influencing any of the other colors in this section, don't put red in. Paint only what you actually **see**!

Take note of any discoveries you make. At the end of your painting, each section should have a slightly different color cast because you were concentrating on seeing a particular color in that section.

Repeating this assignment a number of times will develop your ability to see more color in any subject you paint. One of the distinguishing qualities of a beginning painter is the use of local color (limited color). A novice painter will paint a blue object using only tints and shades of blue rather than recording the nuances of other colors that are reflected onto that blue object from nearby objects. This assignment will help you go beyond the use of local color and into a more sophisticated manner of recording the reflected color present in the world around you.

Assignment Start
The divisions in your drawing for assignment 19 may look something like this.

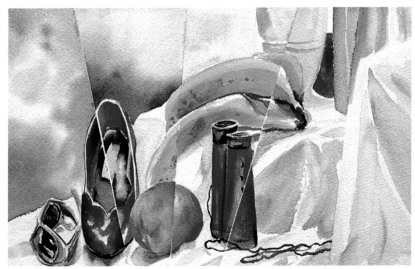

Assignment Finish
You are able to see the divisions in this work because of the color shifts between each section of the painting.

COLOR STUDY
Ron Tate
Transparent watercolor
15" × 22"
(38cm × 56cm)

Creating Luminosity Through Contrast

One of the wonderful characteristics of transparent watercolor is its potential for creating luminous paintings. Light is really an active part of the medium as it passes through the transparent layers of paint, contacts the surface of the paper and bounces back into our eyes. It is a natural for communicating light within our works, if we know how to use the color properties involved: (1) *hue*, the color itself, (2) *value*, the lightness or darkness of a color, and 3) *intensity*, the brightness or dullness of a color.

A Formula for Creating Luminosity

You can create luminosity by creating contrasts in the three properties of color (hue, value and intensity). Imagine that you want to paint a picture that features a sunset. You want to make the sky look luminous. How would you do that?

1. Make the sky lighter in value than the land (value contrast).
2. Choose a warm color for the sky and a cool color for the land (hue contrast).
3. Make the sky colors more intense than the land colors (intensity contrast). Dull the colors of the land surfaces by mixing their complements with them.

That's all there is to it! You can make any subject in your paintings look luminous by establishing contrasts in the three properties of color.

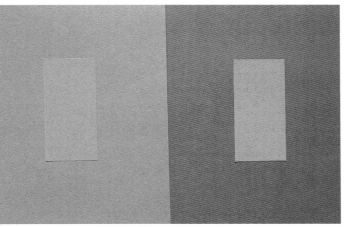

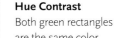

Value Contrast
Both yellow rectangles are the same color. Which one looks lighter?

The yellow rectangle on the *left*. Why? Because of the extreme value contrast between the yellow and black. The dark background emphasizes the lightness of the yellow.

Hue Contrast
Both green rectangles are the same color. Which one looks brighter?

The green rectangle on the *right*. Why? Because the red background sharply contrasts with the green. Complementary colors provide the greatest contrasts in hue.

Intensity Contrast
Both blue-green rectangles are the same color. Which one looks brighter? The blue-green rectangle on the *right*. Why? The rectangle on the right has been placed against a gray background with low intensity. We could make the blue-green rectangle appear even brighter if it were placed against its dull complement (dull red-orange), as you learned in the chapter on color. This way we would not only have a contrast in intensity but also in hue.

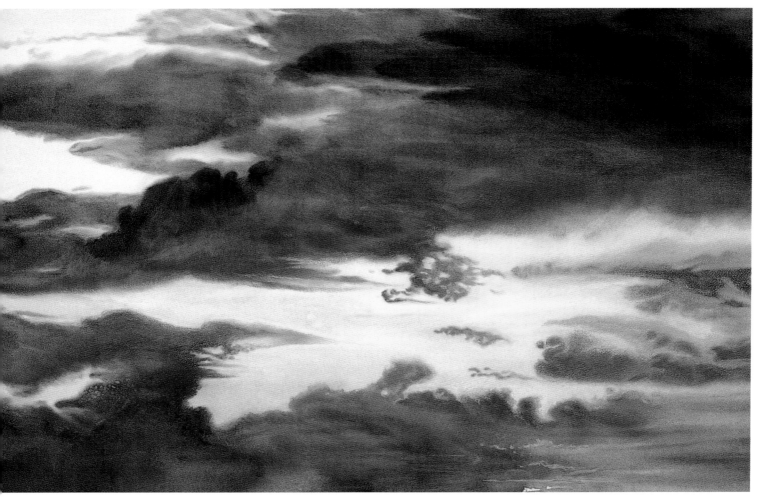

The luminous areas of the sky have been created by contrasting them with the dark, dull, cool colors of the clouds.

SKY LIGHTS #2
Linda Stevens Moyer
Transparent watercolor and watercolor crayon
40" × 60" (102cm × 152cm)
Collection of Robert Dunlap, Rolling Hills Estates, California

You can see the luminosity formula in action in this painting. It is composed primarily of complementary yellows and violets (hue contrast). The parts of the painting that I intended to be luminous were kept brighter and lighter than the surrounding areas of the rocks (intensity and value contrast).

WATER LIGHT #20
Linda Stevens Moyer
Transparent watercolor
29½" × 42" (75cm × 107cm)
Collection of National Medical Oxygen Co.,
Orange, California
Received Gold Medal of Honor for watercolor
from Allied Artists of America

This is an example of backlighting. By making the birds relatively dark and dull in color and the background lighter and brighter, the light in this painting seems to come from beyond the foreground.

FEATHER LIGHT #9
Linda Stevens Moyer
Transparent watercolor
42" × 29¹/₂" (107cm × 75cm)
Collection of Aryna Swope, Los Angeles, California

I made these pink blossoms look luminous by contrasting their light, bright colors with a background that is primarily green, dark and dull.

ANGELWING BEGONIA
Linda Stevens Moyer
Transparent watercolor
40" × 60" (102cm × 152cm)
Collection of Bill and Margaret Brummel, Mission Viejo, California

Different Color Systems

We can do a lot to change the appearance of the colors in our paintings simply by understanding the relationships between hues, values and intensities, and what will happen when one color is placed next to another. The Color Field painters of the 1970s experimented with these principles in their paintings.

A color will appear brighter when surrounded by its complement. It will appear even brighter if you dull that complement. You can make a color look lighter by surrounding it with a darker value. You can even make a color appear to change hue by placing certain colors next to it.

There are different primary color systems for different mediums, and as a painter it will help you to understand the differences between them.

The Subtractive Primary Systems

The process that we use in mixing paints is a subtractive one. For example, when red, yellow and blue (*primary colors*) are mixed together in equal weights, the wavelengths of light reflected by these pigments cancel each other out. In other words, wavelengths are subtracted and the result is black. This system has been used in this book. It is essential for you to understand and use this system when mixing paints.

Another subtractive primary system is used in printing. In this system images are formed from the juxtaposition of small dots of color. In this case, the primary colors are cyan, magenta and yellow (*subtractive primaries*). Black is also used in this process.

The Additive Primary System

The primary colors in the additive system are red, blue and green. These are used in film, television, computer monitors—wherever we are actually mixing light. These are called *optical primaries*. When different colors of light are mixed, the resulting color is lighter because more light is added. Notice that the complements in the additive primary system are very different from those for the subtractive painting process. When using the additive system, to make something look more red, you would subtract cyan (the complement of red) from the mixture.

When viewing a painting, we see light reflected from the painting's surface. Because the viewing process involves pure light, the system of optical primaries (and complements) comes into play.

In order to make a color look more intense, you would surround it with its dull optical complement. For example, if you want a yellow flower to look very intense, place a dull blue next to it (rather than the dull violet used in the subtractive painting process). Notice that in both the additive and subtractive primary systems, a pair of complements consists of a warm and a cool color.

Because we must be able to use the subtractive process for mixing paints, it is almost as effective to continue using this system to enhance color brightness rather than incorporating both systems into the painting process. It's your call! Using color is fun and challenging, and you will enjoy the discoveries that you make.

Subtractive Color Wheel for Painting
For painting, the primary colors are red, yellow and blue. The complements of red, yellow and blue are green, violet and orange, respectively.

Subtractive Color Wheel for Printing
Notice that when the three primary colors are mixed, just as in the subtractive painting color wheel, black results.

Additive Color Wheel
In this system, the complements of blue, red and green are yellow, cyan (a blue-green) and magenta, respectively. The center of the circle is white, as all of the wavelengths of color have been combined (added instead of subtracted).

Exercise: After-Images

Stare at the blue moon in the image above. Keep staring for several minutes. Try to keep your eyes focused only on the moon. Then look at the next illustration and focus your eyes on the black dot. What do you see?

The colors that you should see are called after-images. You see the additive complementary colors that correspond to the colors in the first image.

You see these colors because we are now working with the medium of light. The colors of light bouncing back from the surface of the page have influenced the rods and cones within your eyes. The sustained view of these colors when focused on a white piece of paper produces the optical complements of those colors.

The yellow flowers in this painting appear particularly vibrant because many of them are juxtaposed with areas of blue, which is the optical complement of yellow.

TEXAS SUNFLOWERS
Hilary Page
Transparent watercolor
22" × 30" (56cm × 76cm)

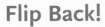

Flip Back!

The painting displayed at the beginning of this chapter, *Wasatch Winter #2*, uses the additive primary color system to emphasize the light coming through the brush onto the snow.

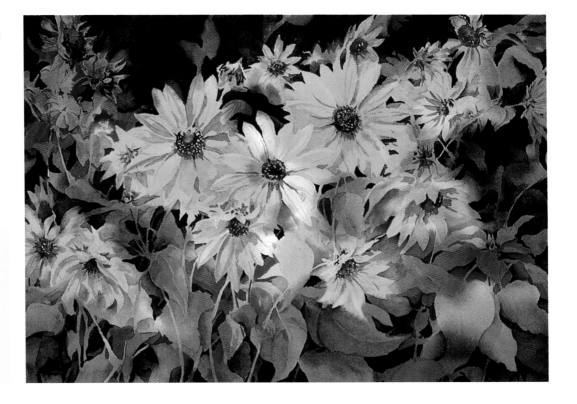

Pointers Before You Paint

THERE ARE MANY DIFFERENT WAYS to use photographs to develop paintings. This chapter will cover the whys and hows of photo references, and will show examples of some of my paintings that have made use of this visual resource. I've also provided some helpful hints and reminders as you prepare to make a painting.

WATER LIGHT #33
Linda Stevens Moyer
Transparent watercolor
29¹/₂" × 42" (75cm × 107cm)
Collection of the artist
Photograph by Gene Ogami
Received Gold Medal from the
American Watercolor Society, New York

Using Your Camera as a Sketchbook

For many years I worked only on location, from still life or from live models, to develop paintings in oil and watercolor. I still believe that working from "the real object" is essential for a beginning art student in order to learn how to represent space, volume and light.

My use of the photograph as part of the painting process began in 1977. I had discovered a beautiful ravine located between Corona del Mar and Laguna Beach in southern California. My first view of it was from the highway, and the eroded land surfaces illuminated by the afternoon light were magical. I had my camera with me and I took several shots of the ravine. I was just as enchanted with the images when I looked at the photos later, and I decided to explore the ravine with the objective of using it as subject matter for a series of paintings.

The site of the ravine was enclosed with barbed-wire fencing and marked *No Trespassing*. I found it necessary to crawl through the wire to explore the full length of the ravine that ran back into the foothills. It was very cumbersome to take painting supplies with me, and, of course, I confronted the usual obstacles of the weather, constantly changing light and shadows, and a variety of wildlife including coyotes, cows, wasps and bees. I was leery of being caught in a prohibited area.

The terrain seemed to change every time I visited due to rain that brought more greens into the landscape or hot, dry winds that bleached and warmed the colors of the brush. Using the camera to record the many colors, shapes and volumes of the ravine seemed to be a natural solution to the problems I encountered.

The series of paintings based on the ravine turned into a project of over two

FORGOTTEN PLACE #8
Linda Stevens Moyer
Transparent watercolor
22" × 30" (56cm × 76cm)
Private collection

Reference Photo
I worked from this slide when painting *Forgotten Place #8*. The name of the series has turned out to be quite prophetic, as the ravine was filled in and this area is now a golf course. Images of the original ravine exist only in photographs and artists' works.

years, portraying the area at different times of the day and year. The result was twenty-six full-sheet watercolor paintings in a series I call *Forgotten Places*. The process of using photos to develop my paintings has continued as a result of this early experience.

The Benefits of Using Photographs

I work only from photographs that I have taken. I've found that using photos has freed me in a number of ways. I have a wonderful record of the subject matter. I don't have to worry about changing light or weather conditions. I can work every day if I choose. I can work on a painting as long as I wish. It takes only a few seconds to take a photograph, whereas sketching requires much more time. A camera and a few rolls of film can record several hundred "photo sketches," and they take up almost no storage space.

I have many photo resources now at my disposal (literally thousands of photographs in my slide bank!), and I am free to play with many different compositional ideas. To develop a composition, I can use one or more photos in combination with other sources such as real-time observation, invention and black-and-white photos. I also have the option of spending more time considering the development of a composition because I view a resource on location and then several times back in the studio before making a decision about using it in a painting.

How to Take Useful Photographs

I use a 35mm single-lens reflex (SLR) camera with two different zoom lenses: 28-80mm and 75-300mm. My camera can be set for automatic use, or the exposure setting can be manually controlled.

I usually have an idea in mind for a series of paintings that will be based on a particular subject. Periodically, I take a day or so to use my camera as a sketchbook. Many times, I will plan my vacations around a certain locale that will

Slide Files
I had special drawers built into a cabinet in my studio to accommodate slides of my completed paintings, as well as resource slides and other slides that I use in teaching. I catalog the resource slides according to their content. For example, part of my slide storage is labeled *Flowers*. I then break this category down into images of specific flowers and alphabetize those categories. Then it's very easy to locate the images that I need when I'm developing the composition for a painting.

make it possible for me to take photos of a subject that currently interests me.

When taking photos, I look through the viewfinder on my camera and assess the abstract formal qualities within that rectangle. I look for interesting shapes of light and shadow. I try to find dynamic, directional movements of line and shape. I determine what the focal point of that particular view is and make sure that it will be off-center in the photograph. Eventually, assessing the compositional value in the viewfinder becomes an instinctive thing; it becomes possible to immediately recognize whether or not the composition seen through the viewfinder is a viable one.

I usually take more than one shot to give myself plenty of compositional possibilities. Try:

- Focusing on several different depths in the view (foreground, middle ground and background).
- Capturing several different angles or views of the subject.
- Manually controlling the settings on the camera to provide different exposures (bracketing shots one half stop above the indicated exposure, at the recommended exposure, and one half stop below the indicated exposure). This is particularly helpful when taking photos of snow or clouds or when the amount of light reflected from the subject is in question.
- Shooting the main subject matter from various distances. This helps when you need more detail or if you decide to make the center of interest more prominent in the painting.

 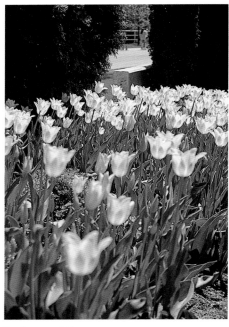

Foreground Focus
In this photograph, I focused on the tulip nearest to me.

Middle-Ground Focus
Focusing on the tulips in the middle ground gives me essential information needed to develop form and detail in this spatial area of the composition.

Background Focus
Photographing the tulips with the focus on the background provides more information and yet another option in developing a composition.

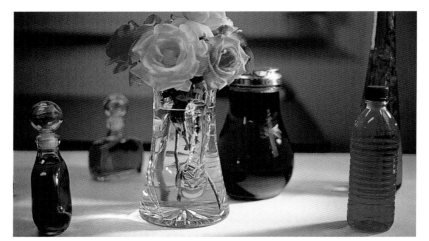

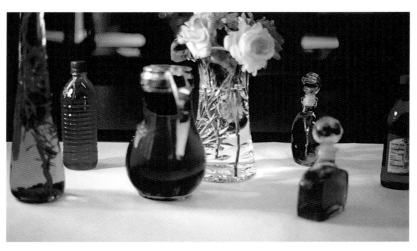

Change Your View
Each of these views gives the opportunity to better understand the form and lighting of the various objects in the still life. The views also provide options for developing different compositions based on the same still-life arrangement.

Working With Slides

Some artists work from photo prints. I work from slides because:

- They usually provide more information than a print. Sometimes there are dark areas in a print that hide essential details. This is less likely to occur in a projected slide.
- The color is better. The light that passes from the projector through the slide results in brighter and clearer colors than can be achieved in a print.
- There is more feeling of light in slides than in printed photographs.
- The slides are easier to store and catalog than prints.
- I can project the slides very large to see details.

Viewing Tools

Above: This is the small light table that I use in my studio. *Top right*: This is the rear projection screen that fits into my suitcase. It's approximately 19" x 26" (48cm x 66cm). I use a larger one in my home studio. *Bottom right*: This is my slide viewer. There are a number of these products on the market.

Evaluating Your Slides

When I receive slides back from the photo lab, I look at them on a small light table. What I look for first is interesting light and dark shapes. Many times this creates an idea for a composition. I stack the slides that have the most interesting dark and light shapes in one pile.

I then project these images to examine the detail. Is it clear and sharp? Do the shadows conceal too much detail? Am I still interested in the formal abstract qualities of the photo? Do I see possibilities for developing an interesting painting? Am I excited about them? I keep carousels of slides that pass these tests. They aren't always the images I was most drawn to when I shot the photos. There are always some surprises in each roll of film.

Viewing Slides as You Paint

There are two different means that I use to view the slides while I am painting: a slide viewer and a rear projection screen. Both of these allow me to view slides in a well-lit studio.

THE REAR PROJECTION SCREEN

You will need a slide projector to project the slides onto the screen. I bought my first screen from a camera supply store. When I began to present workshops nationally, I asked my husband to build one for me that would fit inside my suitcase so that I could have it with me to show to my students.

The construction process is really quite simple. You will need the following materials: wood strips (simple molding), a piece of frosted Mylar, white glue, a staple gun and staples, metal *L* brackets, bolts, nuts and washers. Two rectangular frames are constructed from the wood strips to match the size of the Mylar. The Mylar is sandwiched between the two frames and fastened securely, first with glue and then with staples (which penetrate through one side of the frame into the Mylar). The screen is then reinforced and strengthened by placing the brackets in each corner. These are bolted into the wood and fastened with washers and nuts on the

reverse side. In order to make the screen stand, my husband simply routed out a piece of wood to create a slot that the screen would fit into.

When I paint, the projector is aimed at one side of the screen. I stand on the other side and I am able to see the projected slide very clearly without having to turn the lights off. I can project the slide as large as the screen itself if needed. The only disadvantage of this method is the cost of the projector bulbs. Depending on the life of the bulb and the length of time that I work, I may use one or more bulbs for each painting that I complete. However, I work on a painting for several weeks or months depending on the size and the complexity of the work.

THE SLIDE VIEWER

The other device that I use is a viewer that has an 8" × 8" (20cm × 20cm) screen. The bulbs are very inexpensive and I usually find myself working from both the slide viewer and the rear projection screen.

Using Photographs to Develop Paintings

Most of my paintings are from multiple resources. I may have a concept or an image that comes to mind, or perhaps a visual resource will stimulate the idea for a painting. I follow up with research to find images that will enable me to create a painting with the degree of reality that I require for that particular work.

When working from photographs, the artist should be aware that there is a certain look that a photograph may give a completed painting. The background may be out of focus or the image distorted by the camera. I've seen numerous paintings in exhibitions that obviously were developed from a single photograph rather than from a process where photographic resources were used as aids to the artist's vision. These paintings may have the sterile look that comes from the neutral view of the camera lens.

There are many different ways to use photographs to develop paintings. These examples are just a few. I hope that they will help you to understand how various resources may be used to develop a painting and to enhance creative vision.

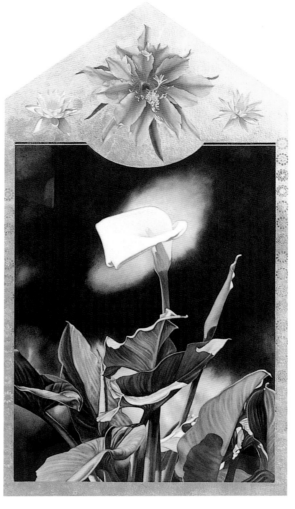

CONSIDER THE LILIES
Linda Stevens Moyer
Transparent watercolor and
23-karat gold leaf
60" × 33¼" (152cm × 84cm)
Permanent collection of the Springville
Museum of Art, Springville, Utah

A "Rough" Beginning

Sometimes I begin with a very rough, gestural sketch of an idea along with notes about the concept that I'm trying to bring to the painting. *Consider the Lilies* began in this way. As you can see, the initial sketch for the piece was very rough! The math on the right side of the sketch helped me to work out the dimensions of the painting.

Once I had an idea of what I wanted to do, I began looking through my slide resources, and the final concept for the painting gradually developed. In the preliminary drawing, I had planned to feature three calla lilies. This was revised and the completed painting has only one that is in full bloom. I felt that focusing the light on one blossom would be more dramatic and would also help to clarify the intent of the piece. I chose flowers from three different slides for the top triangular portion of the painting. The gold leaf panels on the sides were added to accentuate the preciousness of the subject matter and were designed to enhance the composition by adding flower-like medallions along the sides.

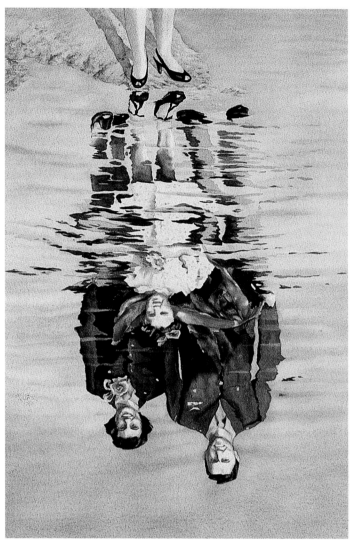

Resource #1

I found a slide that I had taken years previously of a spar of land. This served as the ground for the placement of my adult feet and legs. I observed my image in a mirror to draw in my adult feet and legs (at the top of the painting).

Resource #2

The images of the figures were taken from a black-and-white photo of my aunt and uncle's wedding. I was the flower girl. My mother still had the little dress that I had worn, and I used that to help me understand how to develop the color of this section of the painting.

I eliminated the figures on each side of the photo and then drew it upside down. I made it resemble a reflection in the water by breaking up the image and distorting outlines of the figures as I drew them on the paper. The water was invented without having any additional resource.

Pooling Your Resources

Water Vision #2 was developed by using several different resources: slides, real-life observation and an old black-and-white photograph. I had a mental picture of what I wanted the image to be. I then looked for visual reinforcement that would enable me to create the painting.

WATER VISION #2
Linda Stevens Moyer
Transparent watercolor
42" × 29½" (107cm × 75cm)
Collection of Michael and Nancy
Mooselin, Newport Beach, California

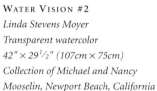

Resource #3

The koi in the central part of the painting came from portions of two slides that I worked with to create shapes that would complement the rest of the composition.

TRANSFERRING AN IMAGE TO WATERCOLOR PAPER

step 1 | MAKE A DRAWING ON TRACING PAPER

A drawing of an iris was made on tracing paper in preparation for its transfer to watercolor paper. Make your drawing the same size that you want the finished painting to be. You may want to go over your pencil lines on the tracing paper with a ballpoint pen so that you can easily distinguish them once the graphite has been added to the back of the paper.

step 2 | BLACKEN THE BACK OF THE PAPER

Turn over the tracing paper and blacken the back of the paper with a soft no. 2 graphite pencil wherever lines occur in the sketch.

step 3 | REMOVE EXCESS GRAPHITE

To eliminate some of the excess graphite from the paper, gently rub the paper with a tissue. Some artists use a tissue that has been moistened with rubber cement thinner or a non-oily lighter fluid. This will set the graphite and prevent smudging during the tracing process.

step 4 | TRANSFER THE DRAWING TO WATERCOLOR PAPER

The tracing paper has now been treated so that the back of it will act as a carbon. Make sure that the side with the treated graphite is in contact with your watercolor paper. Fasten the tracing paper to your watercolor paper with paper clips so that it won't move while you are tracing the image. Using a different colored pencil or a pen will help you to see where you have gone over the lines. Press hard enough to transfer the graphite onto the watercolor paper, but not hard enough to emboss the paper. You have now transferred your drawing to the watercolor paper and are ready to begin painting.

Helpful Hints

We have covered the basics of transparent watercolor. Now it's time to put all of the information into practice. The next few pages will provide a few valuable hints and points to remember as you paint.

HINT #1 | Make thumbnail sketches when planning a composition.

These very quick, small sketches of a possible composition can be done in seconds. It is important that the thumbnail sketches be placed in rectangles that represent the shape of the paper that you will be using for your final composition. In other words, don't plan a composition in a square rectangle that will eventually be painted in a long, thin rectangular format.

HINT #2 | You may want to work out your composition on a piece of tracing paper and then transfer it to your watercolor paper.

This will eliminate a lot of erasing that can damage the surface of your watercolor paper.

HINT #3 | A viewfinder is very helpful in developing and drawing compositions.

It enables you to look at a still life, landscape, figure or other subject matter and eliminate those parts that you don't want to use in your composition, or those portions which will be distracting to you.

step 1

Using your ruler and pencil, draw pencil lines as indicated by the red dotted lines on both of your index cards.

step 2

Cut along those dotted lines on both cards. Now draw a dotted line ⅜" (1cm) below the top of each card (see the green dotted line).

step 3

Fold each card along the dotted line, then fit the two cards together in this manner.

Finished Result

When you slide the cards together, you will have a viewfinder that looks like this. Notice that you can slide the two cards back and forth along the channels you have created to make windows of different shapes. If you are planning to create a long, thin composition, you can move the cards so that a long, thin window is the result. If you decide to work in a square format, you can move the cards to create a square window to look through. The paper clips are to anchor the cards in the position you wish to work. Clip at the top and bottom to hold the cards in place.

HINT #4 | **Many watercolor artists wash their paper down and then let it dry before painting.**

This removes some of the sizing from the surface of the paper and makes it easier for the paint to stick. Sometimes, if the sizing isn't removed, the paint will seem to be repelled by the paper and it will be hard to get good coverage. You'll notice small specks of white paper in your washes; this is where the sizing resisted the paint.

You can wash down your paper by applying a lot of clean water with a very large flat brush, working from the top of the paper down with overlapping strokes. (You will have a wet floor if you don't have something to catch the water.) Use the brush lightly; you don't want to distress the paper surface. If you have previously stretched your paper the sizing has been washed off already.

I have used the garden hose on very large sheets of paper, 40" × 60" (102cm × 152cm) or larger. The key here is not to use a forceful water pressure as this will distress your paper and marks will appear as you work on your painting.

It isn't absolutely necessary to wash the sizing off. Some artists prefer to work on a surface that has not been washed. I no longer wash the sizing off my paper.

HINT #5 | **Until you are used to the watercolor process, start a painting by writing out the steps you will use to create it.**

Sometimes there seems to be so much to remember! It helps to have the steps written down. Following is an example:

1. Draw the subject lightly on my paper with pencil. Plan for the negative space (background) as well as the positive space (the objects I am painting).

2. Apply masking fluid to all of the small areas that I need to save as white.
3. Use the wet-into-wet technique to paint light colors of the negative space. Let this dry before continuing.
4. Begin to layer the washes, working from light to dark.
5. Etc., etc., etc.

This is only an example. You may find that your notes take several pages. Eventually the steps will become second nature and you won't need to write them down.

HINT #6 | **Because we are working with a transparent medium, remember that the colors put on the paper first will influence the following layers.**

Artists sometimes begin their paintings by washing down the surface with one or more light colors to influence the appearance of the final painting. For example, if I want a finished painting to have a golden light, I may begin by washing down the entire surface of the paper with a very light application of Cadmium Yellow. Layering colors to achieve new colors is an exciting part of transparent watercolor.

HINT #7 | **Watercolor dries lighter and duller than it looks when it is wet.**

Compensate for this by mixing your colors darker and brighter. Very dark colors and blacks are difficult to mix because so much pigment (and so little water) must be used to create them. When applied to the paper, they will usually look darker when wet than when dry.

HINT #8 | **Try to apply the darks with only one passage.**

Because the paint will be somewhat opaque, if you go back over the dark wash it will tend to streak.

HINT #9 | **There is a simple aid that you can use to combat the left side of your brain.**

Sometimes the left side of your brain will not allow you to see what is actually in front of your eyes. It encourages us to see an object as we think it *should* be instead of how it *really* looks. To combat this tendency, make a "holey card" (as one of my classes dubbed the tool). It is a white 3" × 5" (8cm × 13cm) card with a hole punched in it.

Hold the card away from your eye far enough so that you see only that portion of the subject matter where the color is in question. If you look at a shadow (or other portion of your still life) through the hole, you will be able to compare that small portion of the subject with the white of the card. You will find it quite amazing to discover that some of the colors you thought you were seeing are really quite different. You will also find color in the highlights on the objects. Your holey card will be of value in discovering these colors.

■ assignment #21

Set up a simple still life of not more than five objects. Draw three 5" (13cm) squares on a piece of watercolor paper. In each square draw exactly the same composition from your still life. Tint each square a different color in a very light value: Alizarin Crimson, Ultramarine Blue and Cadmium Yellow Pale. Allow these initial washes to dry thoroughly. Now, paint the objects in each of the squares in exactly the same way.

When you are finished, notice how the beginning wash of color affects the light, temperature and mood of each of these small compositions. Each of the colors that was applied over a beginning wash was influenced by the color of that initial wash. Because no white of the paper was left, the lightest values are that of the first wash.

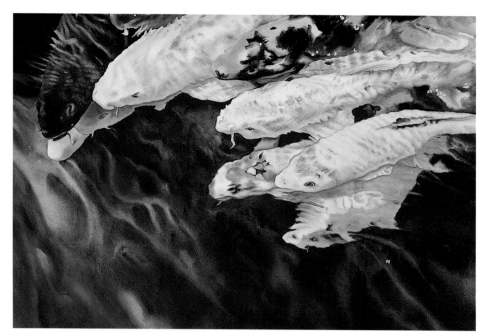

Lifting Dark Colors

Portions of dark colors may be either dry-lifted or wet-lifted from the surface of your painting. I wet-lifted areas in this painting to create the appearance of ripples in the water. The ability to lift through a dark color will depend on the colors that you're lifting. Staining colors will be more difficult to lift.

WATER FLESH #16
Linda Stevens Moyer
Transparent watercolor
29¹/₂" × 42" (75cm × 107cm)
Collection of M. D. Huffman

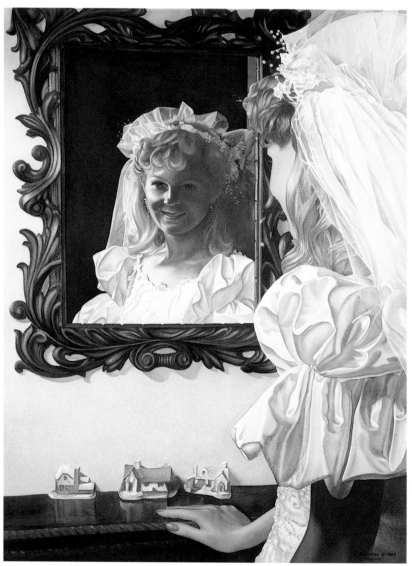

■ *assignment #22*

Arrange the folds of a white sheet or cloth in an interesting variety of shapes. Light this setup from the side with a strong directional lamp and look at it through your viewfinder. Focus on just a few folds that are interesting in relation to each other. Don't take on too much! Make a few thumbnail sketches before deciding on the final composition, then draw it on a piece of watercolor paper at least 15" x 22" (38cm x 56cm). Accurately draw the shapes and shadows of each fold or it will be easy to get lost while painting.

Look at the folds again. Do you see the core shadows, the reflected light on the dark side of the folds, and the many value changes that describe the different forms within the cloth? Note the colors in the shadows. The more you look, the more color will become apparent. Begin to paint, using value opposition to reveal the forms within the cloth. As you paint, continue to look for value and color changes. Carefully recording these differences will give you a real sense of volume and space in your painting.

Cloth Folds

Your painting of assignment #22 might look something like the folds on the dress pictured here.

VIRGINIA
Linda Stevens Moyer
Transparent watercolor
42" × 29¹/₂" (107cm × 75cm)
Collection of the artist
Photograph by Gene Ogami

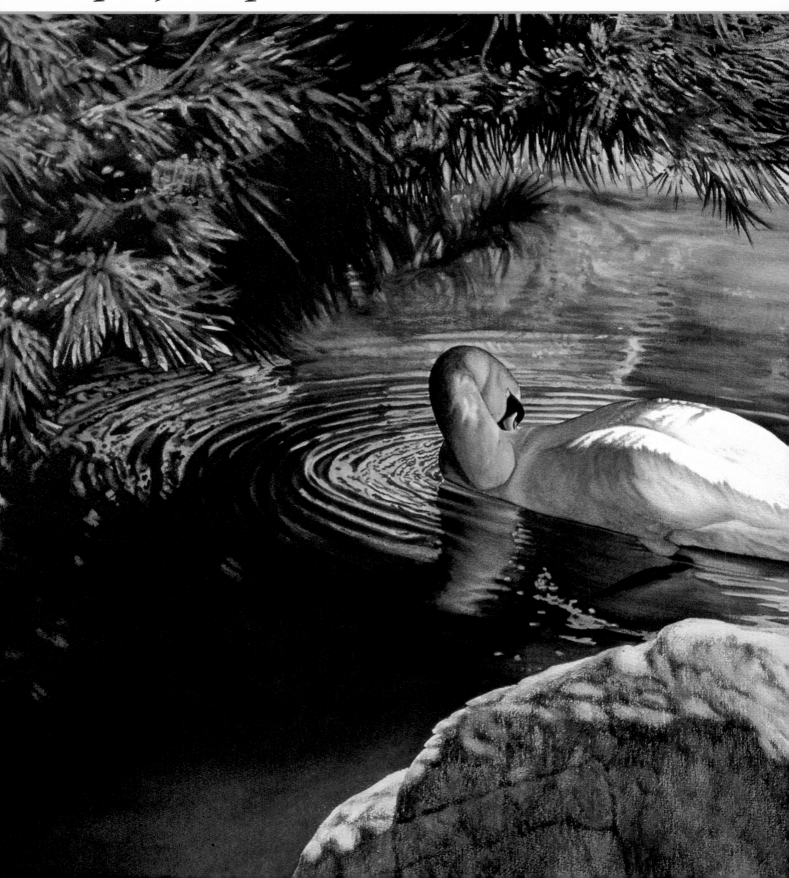

DISCOVER HOW LAYERING WITH transparent watercolor can be an effective means of representing light. Start small with several mini-demonstrations, then put your skills into practice on a few larger paintings.

FEATHER LIGHT #8
Linda Stevens Moyer
Transparent watercolor
29¹/₂" × 42" (75cm × 107cm)
Collection of Joanne May,
Los Angeles, California
Photograph by Gene Ogami

How Layering Works

The Colors I Use and Why

My palette consists of the colors that are listed in chapter one (with the exception of Payne's Gray). They are: the three primary colors of Alizarin Crimson, Ultramarine Blue and Cadmium Yellow Pale; the secondary colors of Cadmium Orange and Phthalo Green; Quinacridone Red (a warm red); Phthalo Blue (a cool blue); and the earth colors of Yellow Ochre and Burnt Sienna. I occasionally bring other colors into my palette if they are needed, but most of my work is based on these colors. With the exception of the cadmiums, the colors are very transparent.

Even though they are opaque, I use the cadmium colors because I prefer the hue of these two pigments. To my eye, Cadmium Yellow Pale is a nice middle-of-the-road yellow—not too orange and not too green. Cadmium Orange reads as a true secondary color to me. Because I work from light to dark, the opaque colors go on first in the layering process. The transparent colors overlay and allow light to pass through their various layers.

One bonus I have discovered is that when a staining pigment is applied over an opaque color, it will lift more easily than if applied directly to the paper. The cadmium colors provide a buffer between a color and the paper.

As you can see, my palette is minimal. Rather than relying on a particular tube of paint for a color, I prefer to "mix" that color by layering. I can create the illusion of almost any color that I need by relying on what I know about color and its properties. In order to layer effectively, a knowledge of color theory and the specific color properties of each tube of color are essential.

The Layering Process

I use the color theory outlined earlier in the book as I layer paint to visually mix color. To create the illusion of light in my paintings, I have found that mixing colors indirectly—overlaying many layers of transparent paint—is more effective than mixing directly—mixing the color on the palette and then painting it in one application. As each color is laid over the previous color, the viewer's eye is able to read through the transparent layers and perceive the mixture that they make.

I liken the process to laying pieces of colored cellophane one on top of another. Light passes through the transparent layers, contacts the surface of the paper, and is then reflected back through the layers of watercolor to the viewer's eyes. Light actually becomes part of the work itself as it penetrates the layers and bounces back from the painting's surface.

Not much of my work is based on chance. I use what I know to build form, color, light and composition. I plan ahead so that there are few surprises. As a result, I rarely lose a painting.

Intuition does come into the process, however. As I paint, I react to the subject, make changes to the composition, light or color, and progressively analyze the work as a whole.

Let's Begin Painting!

The first layering demonstration we'll do is a closeup of the single lotus blossom in the finished painting on the next page. Then we will practice our layering skills with some mini-demonstrations before trying out a few complete paintings.

As you paint, remember to:
- Work from light to dark. This will solve many problems for you.
- Let the paper dry between steps.
- Use brushstrokes economically whenever possible.
- Be patient. It will take time and practice before the transparent watercolor process becomes part of you. The more you paint, the more quickly you will become fluent in this beautiful medium.

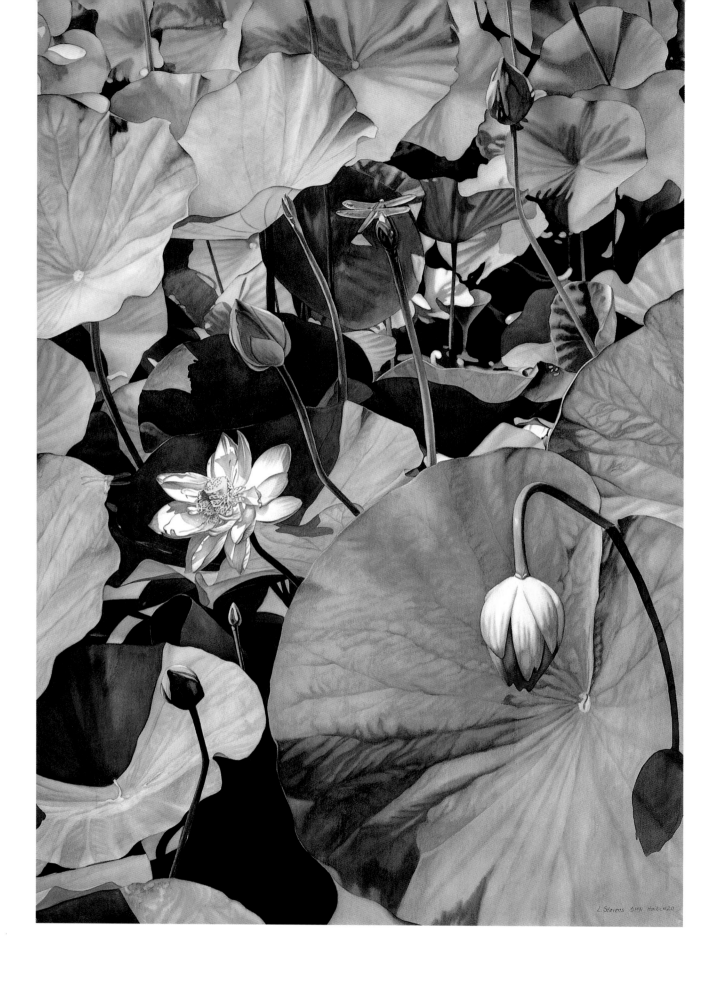

L. Stevens ©1991 Haiku #20

LOTUS BLOSSOM

In this demonstration we'll begin by layering the warm colors first, then the cool colors. Notice that I begin the layering process with the lightest color on my palette.

Reference Photo

PALETTE

Cadmium Yellow Pale

Cadmium Orange

Alizarin Crimson

Quinacridone Red

Ultramarine Blue

Phthalo Green

Phthalo Blue

Burnt Sienna

step 1 | MAKE A DRAWING AND APPLY THE FIRST LAYER

Sketch the composition lightly on watercolor paper. Then look at the reference photo and ask yourself where there is yellow in the composition. Then paint Cadmium Yellow Pale in various tints wherever there is actually yellow or wherever you see yellow influencing another color.

Yellow influences hues such as yellow-orange and yellow-green, and is needed to dull a violet. At this stage of the painting I estimate how much yellow is needed to create the yellow-orange, yellow-green, dull violet and so on that will appear later in the painting. I mix yellow with water to approximate the tint of yellow that I think will be required for each area. In this first step, I complete all of the yellow that will go into the finished painting. Depending on the size and complexity of the image, I may apply only yellow for several hours or perhaps even days.

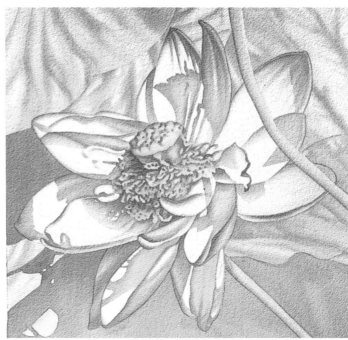

step 2 | APPLY THE SECOND LAYER

When the yellow layer is finished, make sure that it is completely dry before beginning the Cadmium Orange layer. Follow the same process as when you applied the yellow: paint orange wherever you see it or wherever you think it is needed to create the desired color in the finished painting. Layer over the yellow layer or on the white of the paper as needed. For example, for a dull blue to occur in the finished painting, it is necessary to apply a tint of orange to that area. You would also need to decide how much orange is needed in that tint to dull the blue appropriately.

step 3 | ADD THE THIRD LAYER TO FINISH THE WARM COLOR STAGE

Now it's time to layer the reds from your palette. I may use one or both of the reds (Quinacridone Red and Alizarin Crimson) depending on what color of red I need for a particular painting. In this step, only one red (Alizarin Crimson) was used in order to simplify the layering process. Again, paint red only where you see it or where you know you'll need it to optically mix with another color in the painting. Sometimes it's necessary to come back with another layer of a color that you're working with to create additional intensity and a darker value of that color.

At this point in the process, you have applied at least three layers of color in some areas, and in other places the white of the paper still exists. Notice the yellow-oranges and red-oranges that have resulted from the layering process.

Layering | TIP

When applying each layer of color, make sure the previous layer is completely dry, and use a light touch—only as many brushstrokes as necessary to fill in the area. (Remember economy of brush-stroke!) This usually eliminates any unwanted lifting of the previous layer.

Detail

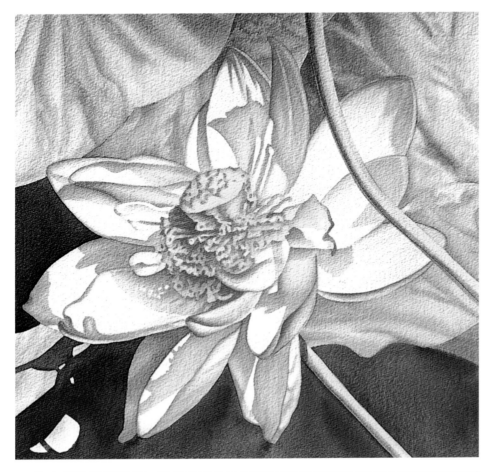

Now that you have completed layering the warm colors, begin using the cool colors. Layer various tints of Ultramarine Blue. (I usually layer with both of the blues in my palette, but have used only one here to keep it simple.) Again, it will depend on the demands of the individual painting. I don't always start with blue when I begin layering the cool colors; sometimes I begin with green. The painting itself seems to dictate which of the cool colors to use first.

Detail

Luminous Beginnings

Notice that the painting is beginning to look luminous because of the contrast between warm and cool colors. This part of the process may seem a little frightening because there is so much contrast between the warm and cool colors and because we haven't reached the final stage of optical mixing.

Layering is not only developing color and varying intensities, but also creating a range of values. We work gradually from light to dark. The detail and textures of the objects also become more apparent as the painting progresses.

step 5 | **ADD ANOTHER LAYER OF COOL COLORS**

Apply tints of Phthalo Green over areas of the painting. A wide range of greens will be created because of the previous color layers. Many times when I begin this stage, I mix various greens on my palette to create an even wider range of greens.

Notice that I layered cool colors in some areas of the white lotus blossom. This would occur naturally because of color reflections from the green foliage around the blossom and the blue of the sky above.

As you work, pay close attention to the edges of the forms. I softened many of the edges in the background with a clean, wet brush to help them recede into space.

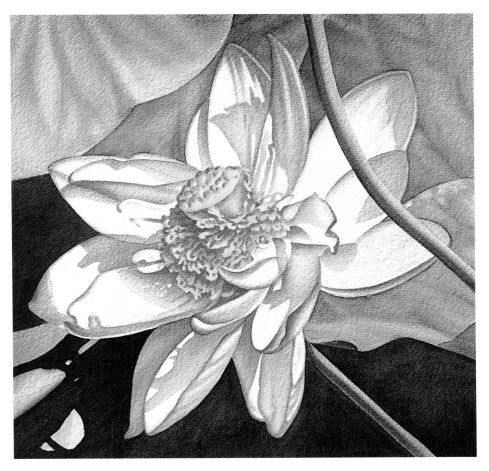

Detail

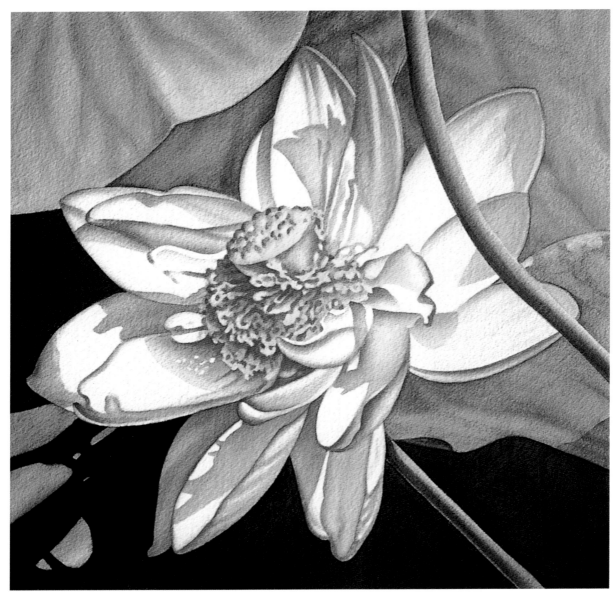

step 6 | **ADD A FINAL LAYER AND EVALUATE**

For the next layer, mix a dark, dull color. For this demonstration, we'll mix a *cool* color. The color or colors used will depend on what will complement the other colors in the painting. I mixed Phthalo Blue, Burnt Sienna and a little Alizarin Crimson to create a dark, dull blue-green. This color was applied in the shadows below the blossom, and in tints in portions of the leaves and petals. Layering tints of this dark, dull color over some of the previous layered colors helps to establish a greater value range, more detail and more unity within the painting.

As you compare this step to the previous one, notice the subtle changes that were made. Now I look at the painting and make any necessary adjustments to the colors. Sometimes none are needed; at other times, I may spend a few minutes or an hour or so to obtain the effect that I want for that particular painting. In this painting no additional adjustments were needed.

LOTUS #2
Linda Stevens Moyer
Transparent watercolor
15" × 15" (38cm × 38cm)
Collection of the artist

ROOSTER

PALETTE

Cadmium Yellow Pale

Cadmium Orange

Alizarin Crimson

Phthalo Green

Ultramarine Blue

Burnt Sienna

Phthalo Blue

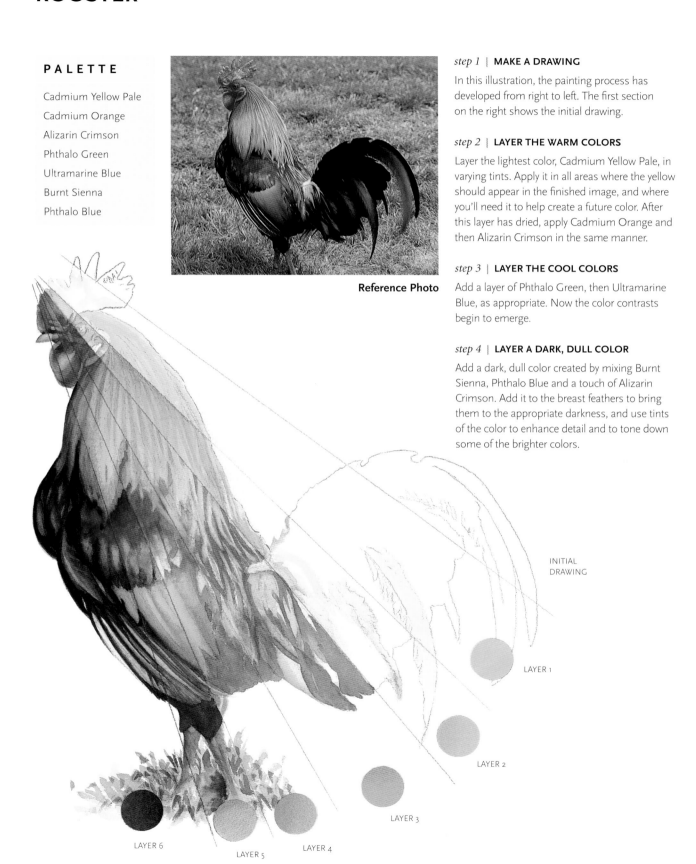

Reference Photo

step 1 | **MAKE A DRAWING**

In this illustration, the painting process has developed from right to left. The first section on the right shows the initial drawing.

step 2 | **LAYER THE WARM COLORS**

Layer the lightest color, Cadmium Yellow Pale, in varying tints. Apply it in all areas where the yellow should appear in the finished image, and where you'll need it to help create a future color. After this layer has dried, apply Cadmium Orange and then Alizarin Crimson in the same manner.

step 3 | **LAYER THE COOL COLORS**

Add a layer of Phthalo Green, then Ultramarine Blue, as appropriate. Now the color contrasts begin to emerge.

step 4 | **LAYER A DARK, DULL COLOR**

Add a dark, dull color created by mixing Burnt Sienna, Phthalo Blue and a touch of Alizarin Crimson. Add it to the breast feathers to bring them to the appropriate darkness, and use tints of the color to enhance detail and to tone down some of the brighter colors.

INITIAL
DRAWING

LAYER 1

LAYER 2

LAYER 3

LAYER 6

LAYER 5

LAYER 4

KOI

PALETTE

Cadmium Yellow Pale

Cadmium Orange

Alizarin Crimson

Ultramarine Blue

Phthalo Green

Burnt Sienna

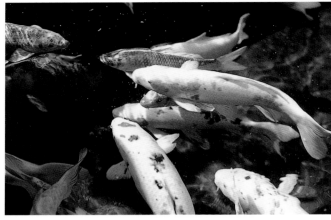

Reference Photo

step 1 | MAKE A DRAWING AND LAYER THE WARM COLORS

Individually layer various tints of the warm colors on your palette (Cadmium Yellow Pale, Cadmium Orange and Alizarin Crimson) over the pencil drawing. As you layer, begin to develop value contrast and detail as well as create a foundation for the cool colors.

step 2 | LAYER THE COOL COLORS

Layer the cool colors (Ultramarine Blue and Phthalo Green) over the previous warm colors. The colors of the fish are very delicate. Only light tints of the cool colors are needed to create additional value contrast and detail.

step 3 | FINISH WITH A DARKER, DULLER COLOR

Add tints of a dark, dull blue created with Ultramarine Blue and Burnt Sienna over some of the previous warm and cool colors. This will help create a more solid definition of form and added detail and value contrast. Only very subtle additions are needed to complete this portion of the painting. Try to visualize how the contrast of a dark, dull, cool color in the negative space would make these fish appear luminous.

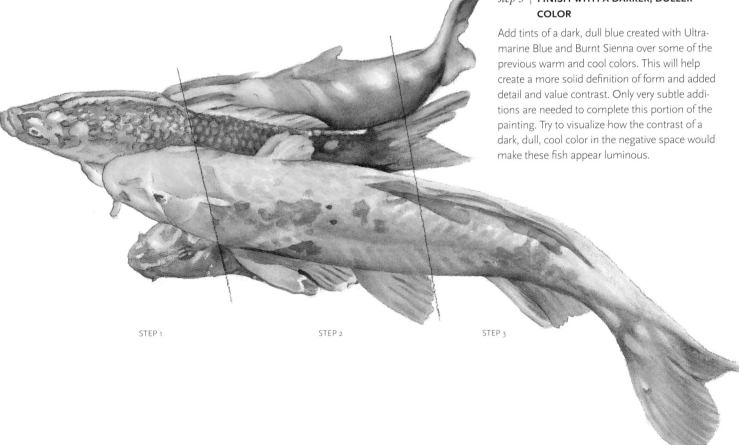

STEP 1 STEP 2 STEP 3

PARROT

PALETTE

Cadmium Yellow Pale
Cadmium Orange
Alizarin Crimson
Phthalo Green
Yellow Ochre
Phthalo Blue
Ultramarine Blue
Burnt Sienna

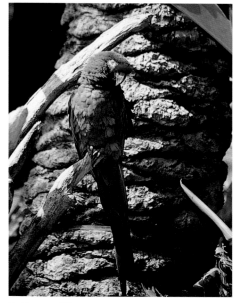

Reference Photo

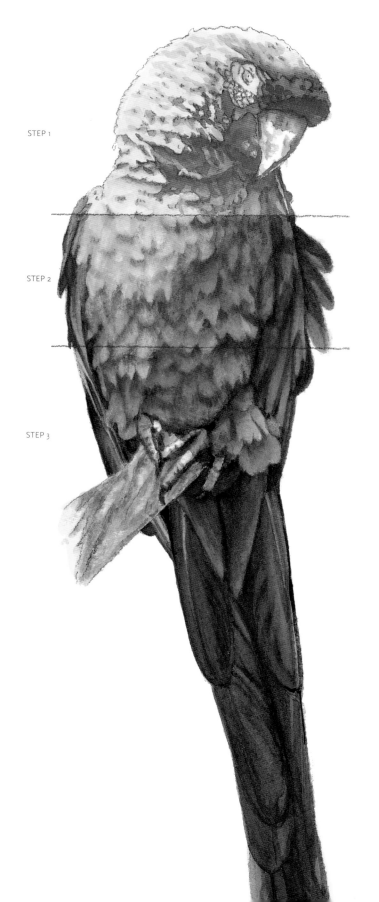

STEP 1

STEP 2

STEP 3

step 1 | MAKE A DRAWING AND APPLY THE WARM COLORS

Begin with a no. 2 pencil drawing, and then layer Cadmium Yellow Pale, Cadmium Orange and Alizarin Crimson. Use several layers of each color. For example, layer Alizarin Crimson in three distinct steps: light, medium and dark. This layering of one color can be seen in the shadowed portion of the parrot's head.

step 2 | ADD THE COOL COLORS

Layer the following colors over the warm colors: Phthalo Green mixed with a touch of Yellow Ochre, Phthalo Green, Phthalo Blue and Ultramarine Blue. Notice how the previously applied Alizarin Crimson dulls and darkens the cool colors. In some areas the warm colors are allowed to come through the new application of cool colors, creating a look of iridescence in the bird's feathers.

step 3 | FINISH WITH A DARK, DULL COLOR

Wherever a color or value change is desired, apply various tints of a dark, dull blue-green (mixed with Phthalo Blue and Burnt Sienna). The effects may be very subtle, but help to establish detail and subordinate the intensity of the previously applied layers.

STEP 1 STEP 2

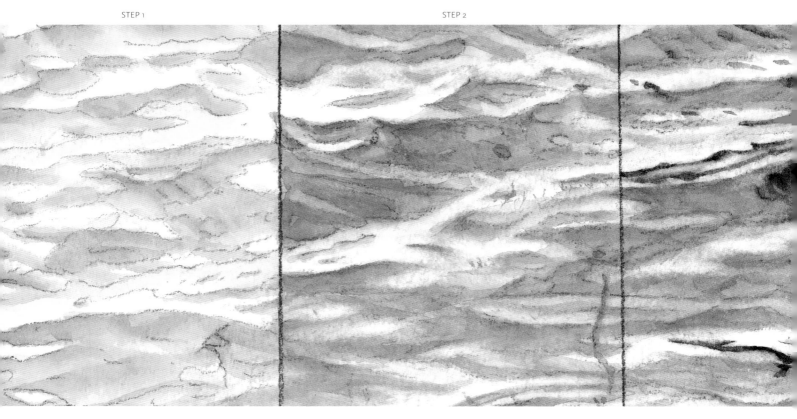

step 1 | MAKE A DRAWING AND BEGIN WITH WARM LAYERS

Lightly pencil in the shapes of the water reflections and shadows before applying layers of Cadmium Yellow Pale, Cadmium Orange and Alizarin Crimson, wherever you detect these colors in the reference photo. Be sure to save the white of the paper where it will be needed in the water reflections.

step 2 | LAYER THE COOL COLORS

Add layers of Ultramarine Blue and some very light tints of Phthalo Green to the near (or shadowed) side of the waves. Continue to guard the areas that will be the lightest portions of the painting.

step 3 | FINISH WITH A DARK, DULL COLOR

Mix your dark, dull color with Burnt Sienna and Ultramarine Blue. Complete the painting by adding this color to the rock shadows and the darker portions of the water reflections.

PALETTE

Cadmium Yellow Pale

Cadmium Orange

Alizarin Crimson

Ultramarine Blue

Phthalo Green

Burnt Sienna

Reference Photo

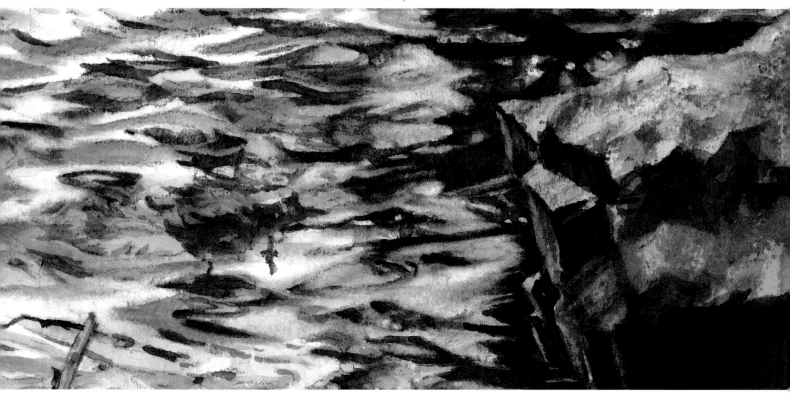

Painting Water | TIPS

Keep these tips in mind when painting water scenes:

- The colors in the sky will always be repeated in the water.
- When painting moving water, make the near side of the waves reflect the color of the high sky and the far side of the waves reflect the low sky. On overcast days, water may appear to have very little color intensity or value contrast.
- The appearance of the water will also be influenced by the color of the bottom as well as any rocks or plants that grow in it (algae, for example).

GLASS CANDY DISH

PALETTE

Cadmium Yellow Pale

Cadmium Orange

Alizarin Crimson

Ultramarine Blue

Phthalo Green

Phthalo Blue

Burnt Sienna

Reference Photo

step 1 | MAKE A DRAWING AND APPLY MASKING FLUID

Begin by doing a detailed drawing of the facets of the glass and the reflections. Sometimes it is helpful to lightly shade where the darker colors will be placed, especially with such a complex subject. Then apply masking fluid to small areas of reflection to save the white of the paper in these shapes.

step 2 | LAYER THE WARM COLORS

Layer the Cadmium Yellow Pale, Cadmium Orange and Alizarin Crimson wherever you see them in the reference photo, or where they will influence another color. After these layers have dried, remove the masking from the colored rim of the glass and soften the edges of the reflections with a Robert Simmons 3/8-inch (1cm) angle scrubber.

step 3 | LAYER THE COOL COLORS

Individually layer Ultramarine Blue and Phthalo Green over the warm colors wherever you see them in the photo. In the lower facets of the dish, begin by applying the cool colors over the masked areas. As this area develops, remove the masking and continue to apply cool colors wherever needed. All masking should be removed before moving on to the next step.

step 4 | FINISH WITH A DARK, DULL COLOR

Add a dark, dull color made with Burnt Sienna, Phthalo Blue and Alizarin Crimson to the previous layers wherever a darker value is observed in the photo.

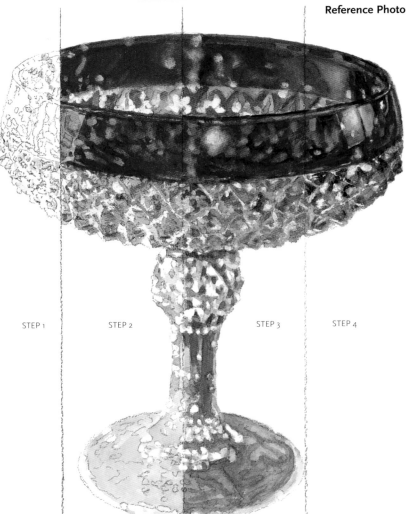

STEP 1 STEP 2 STEP 3 STEP 4

CONE FLOWERS

In this expanded demonstration we will develop an entire finished painting, including the background.

PALETTE

Cadmium Yellow Pale

Cadmium Orange

Alizarin Crimson

Quinacridone Red

Ultramarine Blue

Phthalo Green

Phthalo Blue

Burnt Sienna

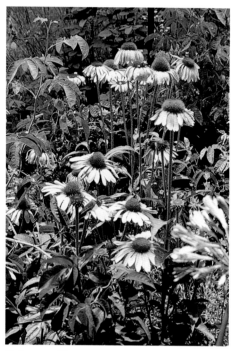

Reference Photo

step 1 | **MAKE A DRAWING AND APPLY THE FIRST LAYER OF WARM COLOR**

Start with a light drawing. As I drew the shapes onto the watercolor paper, I simplified the composition, leaving much of the background foliage out. I also tried to eliminate any contiguous forms by either separating the different shapes or overlapping them. Apply tints of Cadmium Yellow Pale after the pencil sketch is completed. Refer to your reference photo to determine where yellow will be needed in the finished painting. Remember that it must be applied where it will exert an influence on a color that will be applied later on.

step 2 | **APPLY THE NEXT LAYER OF WARM COLOR**

After the yellow layer has dried, apply layers of Cadmium Orange. This should be applied to any shapes of color that appear to contain orange. Notice how the blossom centers are beginning to have form.

Detail

Apply varying tints of Alizarin Crimson. This will begin to develop the pinks of the flowers as well as shadows in many areas of the composition. Notice that much of the negative space has been painted in Alizarin Crimson. This will supply the base color for dark, dull greens. It also helps to simplify the composition so that the flowers, leaves and stems can be seen more easily. Alizarin Crimson has been applied quite heavily to the shadowed portions of the coneflower centers. Quinacridone Red (a warmer red) has also been used to warm and brighten the center portions of the blossoms.

Detail
Here I began to layer Alizarin Crimson in the upper-left corner of the painting.

Detail
In this area you can see some of the warmer red at the top left of some of the cones.

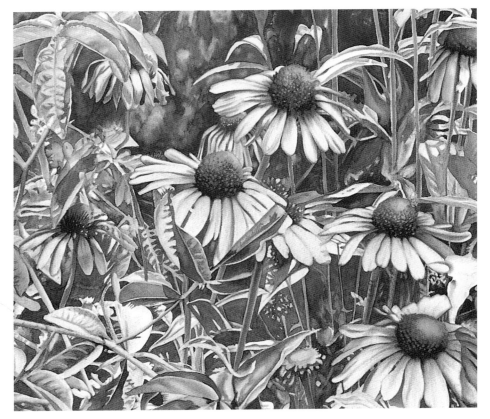

After the red layers have dried, layer tints of Ultramarine Blue over the previous colors wherever indicated by the reference photo. Notice how the tints of Ultramarine Blue have changed the previously layered reds to many different violets. The blue has also dulled many of the oranges to browns.

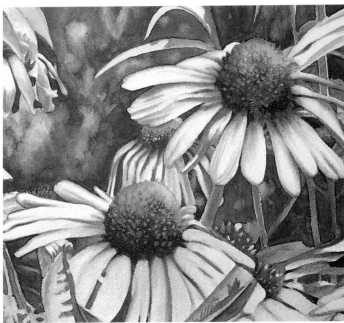

Detail
The layered colors are beginning to produce greens, browns and violets. Notice that Ultramarine Blue was also applied to areas of the blossoms. The blue of the sky influences much of the color that we see in nature.

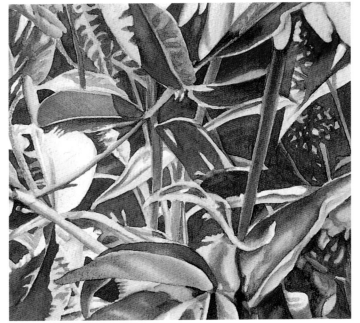

Detail
With the addition of Ultramarine Blue, darker values begin to appear.

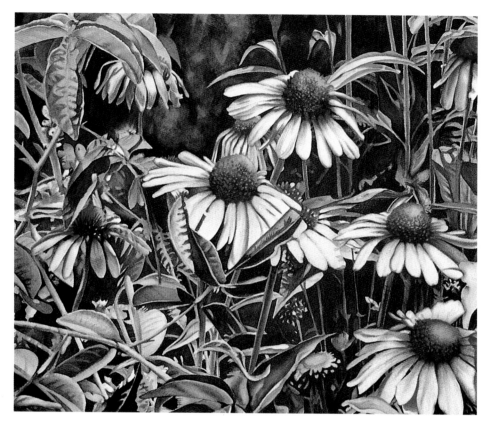

step 5 | **ADD MORE COOL COLOR**

Layer tints of Phthalo Green to continue expanding the color of the painting. Add these tints to the leaves and stems, most of the negative space and even very cautiously to portions of the flower petals. The flowers are surrounded by green foliage, and reflected greens will be seen in the flowers as well. At this point, the painting should begin to lose some of the limited-color look that it previously had.

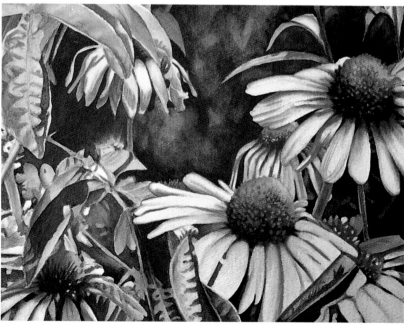

Detail

step 6 | ADD A DARK, DULL COLOR

Mix a dark, dull color with Burnt Sienna, Phthalo Blue and a touch of Alizarin Crimson. You will apply this color in a range from subtle tints to an almost full-value strength of the color. More value contrast is created as these tints are added.

During this step, pay close attention to the appearance of the edges of the forms. Define or soften edges as needed to enhance the atmospheric perspective. As you paint, analyze the structure and form of each plant. Try to make the plants as three-dimensional as possible. Remember to paint the subject so that it exists logically within the simulated space of the painting.

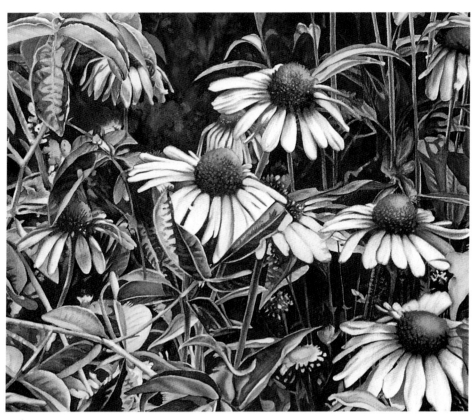

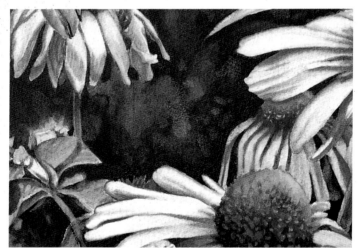

Detail

Detail

Dry-lift some of the paint to create more detail in darker portions of the leaves and the negative space.

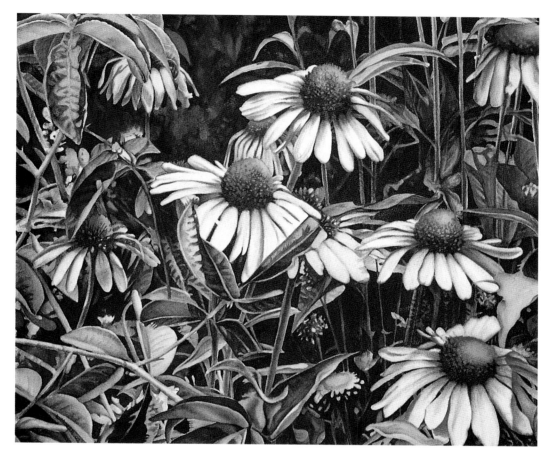

Does the painting work? I decided that I needed to enhance some of the colors in the painting with Cadmium Yellow Pale to create more yellow-greens, to bring some shapes forward in space, and to give the painting a more sunlit look. *Note:* Because Cadmium Yellow Pale is an opaque color, it sometimes will appear to sit on top of the other layered colors.

CONE FLOWERS
Linda Stevens Moyer
Transparent watercolor
19$\frac{1}{2}$" × 17" (50cm × 43cm)
Collection of the artist

Detail

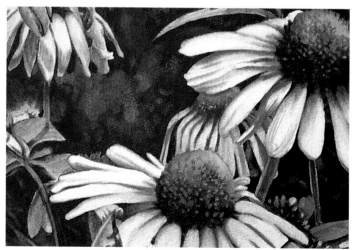

Detail

PALM LEAVES

I took the primary reference photo for this painting—along with many more—when I was in West Palm Beach, Florida, presenting a workshop. I was struck by the strong values and the rhythmic repetition of the palm leaves, and wanted to convey this in the painting.

PALETTE

Cadmium Yellow Pale

Cadmium Orange

Alizarin Crimson

Phthalo Green

Yellow Ochre

Ultramarine Blue

Phthalo Blue

Burnt Sienna

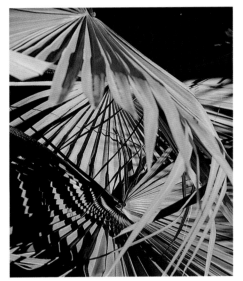

Reference Photo

step 1 | **MAKE A DRAWING AND BEGIN APPLYING THE FIRST LAYERS**

Lightly pencil your drawing on the paper. I left out some of the smaller details of the photograph to simplify and better organize the composition. Then, apply Cadmium Yellow Pale wherever you see it in the photo, and where you will need it to help create future colors. After the yellow has dried, begin applying the Cadmium Orange layer.

Detail

In this detail, you get a closer view of how the two pigments have interacted on the surface of the paper.

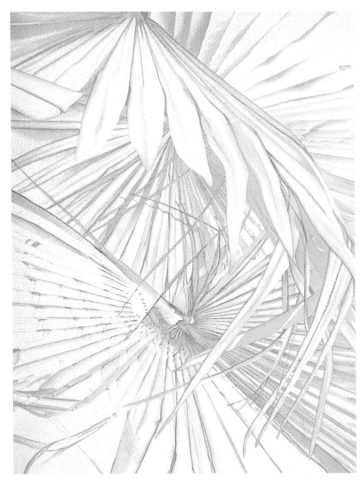

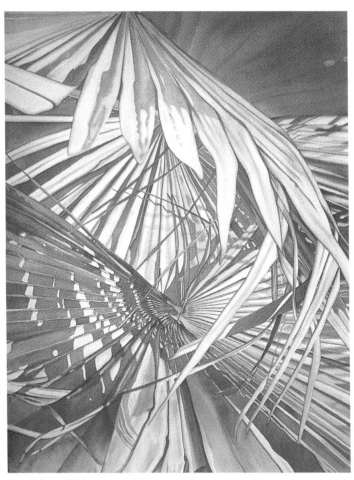

step 2 | **FINISH THE ORANGE LAYER**

Complete the Cadmium Orange layer. Notice how the Cadmium Orange layered over the Cadmium Yellow Pale has created numerous yellow-oranges in the composition.

step 3 | **APPLY THE RED LAYER**

Finish the warm-color layering with Alizarin Crimson, applying it wherever there will be shadows in the finished painting and on the edges of some leaves. The application of red begins to build value contrast and drama.

Detail

Detail

The palm leaves radiate out from this area of the composition. It will be the center of interest in the painting.

119

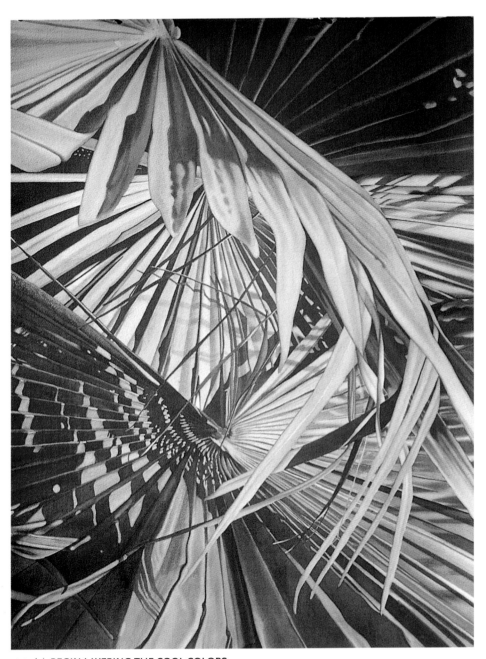

Detail

In this detail we see how the addition of a cool color (green) begins to make the center of interest glow.

step 4 | **BEGIN LAYERING THE COOL COLORS**

Rather than use pure Phthalo Green, mix it with Yellow Ochre to dull it and to make a more appropriate green for the palm leaves in this composition. Layer various tints of the resulting green over many of the previous colors, creating even duller greens (because of the previous layers of red and orange) as well as some yellow-greens.

Detail

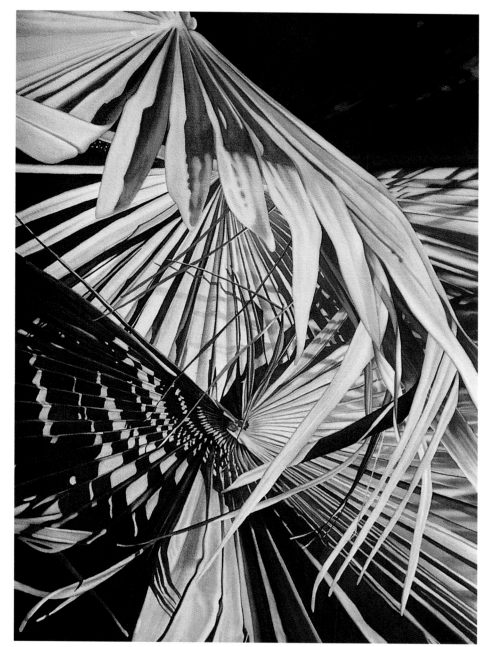

step 5 | **CONTINUE LAYERING THE COOL COLORS**

Add Ultramarine Blue as the next layer to create a range of blues, from a light blue-green to a very dark, dull blue. As the painting progresses, value contrast becomes increasingly more important. Notice how dark portions of the palm leaves become lighter as they cross over other dark areas of the composition. Value contrast enables us to see the crossing of the leaves distinctly and contributes to the sense of space.

step 6 | **ADD THE FINAL LAYER AND FINISHING DETAILS**

Combine Burnt Sienna with Phthalo Blue and Alizarin Crimson to create a dark, dull blue-green. Layer tints of this color over portions of the composition. In the detail above, you can see many of the tints of this dull color that were used to subordinate some of the forms as well as provide additional value contrast.

The viewer's eye is drawn into the center of interest of the painting because of the repetitive forms that converge at this point. The light, bright, warm colors of the center contrast strongly with the cool, dark, dull colors, also focusing attention on the planned center of interest.

Finally, soften the edges of the forms that are farther back in space to help the closer forms pop forward.

Darken some of the cast shadows and thin leaves that cross over the more brightly lit portions of the palm to increase the feeling of space in the painting.

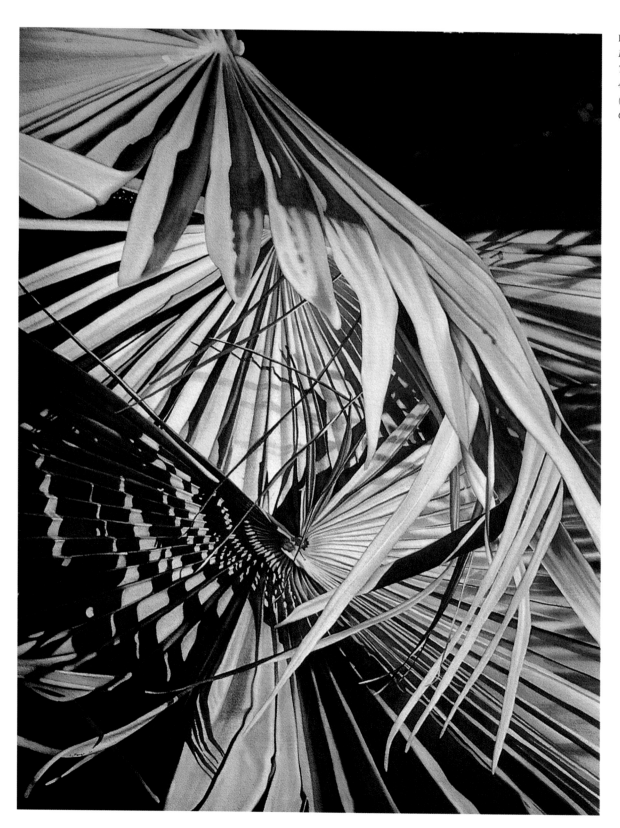

PALM SPLENDOR
Linda Stevens Moyer
Transparent watercolor
42" × 29¹/₂"
(107cm × 75cm)
Collection of the artist

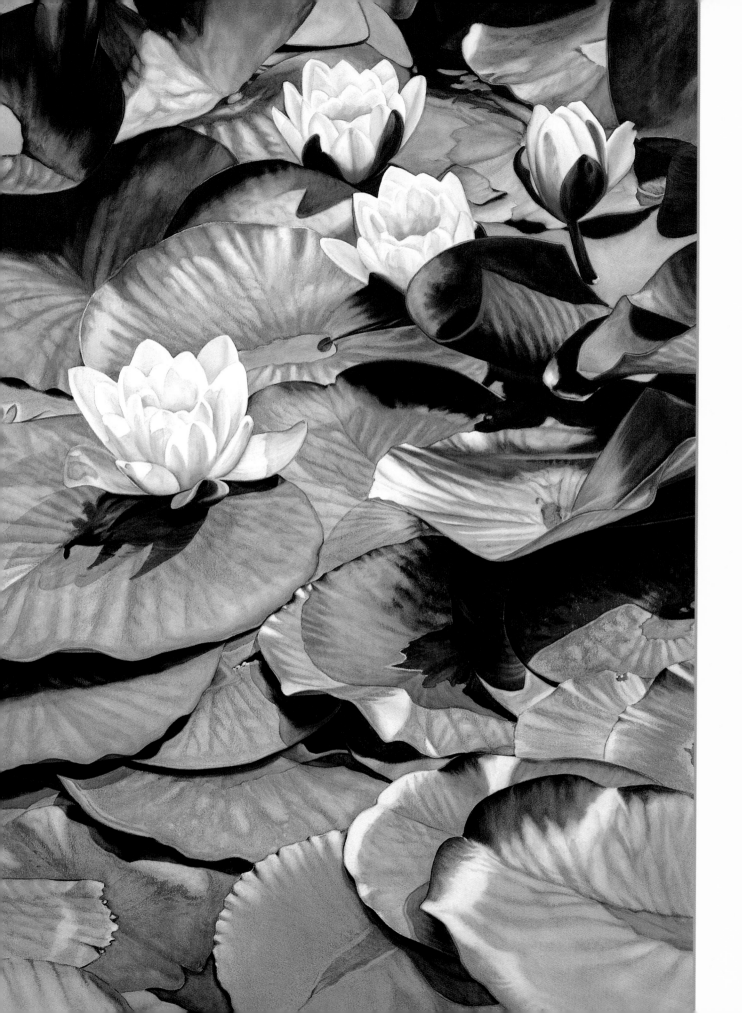

CONCLUSION

■ JOHN RUSKIN, A NINETEENTH-CENTURY CRITIC, said, "Fine art is that in which the hand, the head and the heart of man go together."

When painting, teaching or jurying an exhibition, I think of the hand as the artist's *skill* in using the techniques of transparent watercolor. For me, the head represents the artist's *knowledge* of color, composition, representation of form and space, and the use of the various elements of design (line, value, shape, color and texture). In this book we have dealt mostly with the application of these two aspects in the creation of a painting. However, if we stopped there, the work could not be considered fine art until we brought the third aspect of creation into play: the heart.

The heart is symbolic of the *content* of your work. It goes beyond knowledge and technique. It is the essence of what the artist is trying to communicate to the viewer; it is the voice of the artist. The content of my work has become increasingly apparent to me through my journey as a transparent watercolor painter.

The majority of my paintings have focused on various aspects of nature. In these works, I have always been aware that my obsession with light goes beyond being simply a vehicle for representing the form of an object. To me, light represents the presence of the creator in the created.

As my journey continues, I have found that I want to be more blatant about the content of my work. Recently, my work has begun to take on a different aspect in terms of size, the format of the pieces, the inclusion of precious metal leafs, and the presentation and isolation of the completed paintings in Plexiglas boxes. My intent is to represent nature in an elevated way; to emphasize the preciousness of the world around us; to create paintings that affirm the sacredness of life. I hope that viewers relate to them in a spiritual and also in an ecological way.

Now it's up to you to take the information from this book and incorporate the hand, the head and the heart into your paintings—to create truly fine art. I wish you a wonderful journey of discovery.

HAIKU #7
Linda Stevens Moyer
Transparent watercolor
60" × 40" (152cm × 102cm)
Collection of N.J.C., Inc.,
Malibu, California
Photograph by Gene Ogami

INDEX

WATER FLESH #24
Linda Stevens Moyer
Transparent watercolor
29 ½" × 42" (75cm × 107cm)

The best art instruction comes from
North Light Books!

Packed with insights, tips and advice, *Watercolor Wisdom* is a virtual master class in watercolor painting. Jo Taylor illustrates every important technique and concept with examples, sketches and demonstrations, covering everything from brush selection and color mixing to value and composition. You'll discover tips on finding your personal style, working emotion into your art, creating abstract art and more.

ISBN-13: 978-1-58180-240-5, hardcover, 176 pages, #32018-K
ISBN-10: 1-58180-240-4, hardcover, 176 pages, #32018-K

Create your own artist's journal and capture those fleeting moments of inspiration and beauty! Erin O'Toole's friendly, fun-to-read advice makes getting started easy. You'll learn how to observe and record what you see, compose images that come alive with color and movement, and make a travel kit for creating art anywhere, at any time.

ISBN-13: 978-1-58180-170-5, hardcover, 128 pages, #31921-K
ISBN-10: 1-58180-170-X, hardcover, 128 pages, #31921-K

Beautifully illustrated and superbly written, this wonderful guide is perfect for watercolorists of all skill levels! Gordon MacKenzie distills over thirty years of teaching experience into dozens of painting tricks and techniques that cover everything from key concepts such as composition, color and value, to fine details including washes, masking and more.

ISBN-13: 978-0-89134-946-4, hardcover, 144 pages, #31443-K
ISBN-10: 0-89134-946-4, hardcover, 144 pages, #31443-K

Susan Harrison-Tustain casts new light on painting flowers in watercolor. She shows you how to capture the "essence" of flowers in their natural settings, complete with bumblebees, dew drops and other whimsical touches of life. You'll learn her unique priming method, along with other techniques for creating vibrant colors, realistic textures and lively light.

ISBN-13: 978-1-58180-389-1, paperback, 128 pages, #32444-K
ISBN-10: 1-58180-389-3, paperback, 128 pages, #32444-K